U0001291

火燒島

流氓擺一十五號

UNTOLD HERSTORY

謝三泰

記思往昔，不蹈前轍

綠島之於經歷過台灣民主化黑暗過往的我們，具有指標性的意義與象徵。

2020年，國家人權委員會成立後，我認為人權委員應該前往綠島巡查，所以上任隨即安排。那次前往綠島，同行的有時任國家人權博物館館長的陳俊宏，以及曾經在此受難的陳欽生、蔡寬裕兩位前輩。

我不曾囚於綠島，但有許多老友、戰友、志同道合的前輩、朋友，都待過這裡，因而聽聞過許多有關綠島的故事，當我踏上綠島，過去所聞的「火燒島」故事瞬間具象起來。看到了燕子洞時，自然而然想像起蔡瑞月老師在此翩翩起舞的模樣，一如困於蛛網仍努力展翅的蝴蝶，繭縛的身軀，因不住自由的靈魂；在綠洲山莊聽取導覽時，隔著厚厚的水泥牆與重重鐵幕，穿過獄房條條鐵柵而來略帶鹹味的海風及遠方的海浪聲，是自由的想望與悸動。他們說，當年是不讓政治犯住在二樓牢房的，因為獄方認為看海有助開拓受刑人的胸懷與境界，與牢獄施加受刑人的懲罰苦痛相違背。

「在那個時代，有多少母親為她們被囚禁在這個島上的孩子，長夜哭泣。」垂淚碑上柏楊題的文，一字一句、一筆一畫，深深刻畫出時代的不幸；紀念公園牆上一個個名字，都是一段人生、一個世代的見證與血淚；陳欽生前輩

在面會室吟唱〈母親在何方〉一曲，更是觸動心弦，潸然淚下。是呀，母親在何方呢？

行過13中隊，那是一片向陽、綠草茵茵的坡處，誰能想像，長眠於此的孤魂當初受到什麼樣的對待與苦難？深深的三鞠躬，默哀憑弔在此的前輩先人，也向祂們報告，而今的台灣已然是民主自由之地，請祂們不必再擔心受怕，也不必再驚懼門外的人是不是前來捉捕緝拿的勾魂使者。

綠島新生訓導處及綠洲山莊，是五〇到七、八〇年代見證台灣時代鉅變，也是改變許多政治受難者人生的不義遺址，非常重要。綠島從關押政治犯的監獄，轉變為白色恐怖紀念園區，從法務部管轄轉到文化部，這代表國家面對歷史的反省，這個過程並非一帆風順，如同台灣爭取民主人權的路一般。

轉型正義需要透過不斷與社會溝通對話，才能內化為國家國人共同的價值，因此，除了不義遺址的保存，人權教育的推廣也是重要的工作。

三泰這本攝影集，書名《火燒島：流麻溝十五號》，是講述一九五〇年代，以「思想犯」為名囚於綠島進行思想改造的綠島女生分隊，「流麻溝十五號」即是當時所有綠島政治犯的戶籍地址。這本攝影集呈現那個恐怖的年代，女性政治受難者的青春、血淚與破碎的人生，這些歷史記憶，憑藉著三泰的鏡頭保存與再現，因此，這本攝影集產生了多重的意義，既是珍貴的史料，也是鮮明的映像，重現過去戒嚴時期綠島的肅殺、苦難、不義，也具備文化、教育的功能，透過影像的傳播提醒所有人，特別是未曾經歷那個年代的年輕人，讓他們明白，台灣民主發展的過程曾有如此威權的時代，壓迫、刑罰著主張自由民主的人。

今日台灣的民主自由歷經一條漫長艱難的苦路，從來就不是從天上掉下來的，我們這代走過，希望下一代不要重蹈覆轍，而這需要所有人攜手同心，珍惜民主、守護台灣。

<div align="right">監察院院長兼國家人權委員會主任委員</div>

「過去」已經過去了嗎?

這本記錄攝影集來自四部分的「人」們臉譜,綜合了交錯於不同時間的綠島或與綠島相關的作品。這些作品出自一位生於澎湖的攝影家,不禁令人對島嶼到島嶼的相關性視野產生了高度好奇和聯想!

我曾邀請三泰為《流麻溝十五號》一書(2012年出版)受訪阿嬤拍照,他「抓」住了阿嬤的神采,為讀者帶來了閱讀口述並想像影中人當下生活的樣貌,這是突破口述書傳統編輯的嘗試,讓讀者各自有多樣解讀影像中連結自我歷史意識的情感。

2021年11月,我推薦三泰隨《流麻溝十五號》電影上綠島拍照,才知道這是他第二次上島,也因此看到他拍的幾張1987年甫解嚴後的綠島寶貴照片。而他於解嚴前後開始拍攝政治犯,影像令我印象深刻。

循著電影場景的這些攝影,由黑白照片呈現「過去」,讓讀者驚覺照片是「真實」的過往記錄嗎?這些照片實是「再現過去」的表徵媒介之一,為的是更接近「過去」。讀者閱讀這本書應該會有「忽近忽遠」的感受吧!今天拍攝的「忽近」照片,與綠島1950年代「惟二」政治犯公差歐陽文、陳孟和兩位前輩所拍的「忽遠」照片,形成了對話、互補關係。這些照片拉近了

「過去」對讀者從影像認識歷史的陌生感，在這個意義下，三泰是向兩位美術家、攝影家前輩致敬吧！

現稱國家人權博物館白色恐怖綠島紀念園區的舊政治犯紀念地，與「淡臺灣電影」合作拍攝了時代劇《流麻溝十五號》，博物館與電影都是為了讓觀眾貼近歷史「真實」，讓更多數的大眾容易接近「過去」。紀念地開放了二十年，從最早一張過往的照片都不易取得，到無數的照片與檔案照陸續出現，今天的觀眾已經能夠具體地透過影像更深刻的解讀、體會這裡發生過什麼事了嗎？

舊稱火燒島的綠島，曾經於1951到1965年，以及1972到1990年長期關押政治犯。其中第一階段時期的1951年5月到1954年11月，拘押了百位左右的女性政治犯，至今仍無法完整清查每一位的編號、姓名，及相關檔案。現存的具體影像，是官方「參訪」這些女性政治犯監禁地的宣傳照片；詳細的監獄內細節，除了一本陳勤女士留下的唯一簡要「記事」，許多不為人知的「不安」與「恐懼」之實，現在必須藉助電影「虛構」具說服力的影像來傳達，好讓觀者「感同身受」。

在綠島被稱為「女生分隊」的女性政治犯，按照牢房順時針編號是第八中隊（共有三大隊，合計十二中隊，每一中隊約一百二十人）。女性只有編號，其中包含了出身台南的現代舞先驅蔡瑞月，以及丁窈窕女士。

「流麻溝十五號」是男男女女將近兩千名的政治犯與官兵的總戶籍所在地。2004年，「台灣游藝」文史調查團隊陪伴四位政治犯，訪查綠島南寮戶政事務所，發現了戰後綠島監獄的戶籍紀錄，戶籍號碼早期以「流麻溝十五號」為代稱。政治犯的綠島家書都是透過郵政信箱編號收發，「流麻溝十五號」名號因此得而公開。

綠島可能是近代全球第一個（或是少數）拘禁政治犯與女性政治犯的離島，時空回到冷戰時代1950年代的開端，東亞西太平洋一隅的「思想改造」政治監獄，這個離島長年發生過什麼重大事件？外界所知不多。

這次的照片訴說了一種無法挽回的過去，而「過去」真的已經過去了嗎？還是不斷干擾著今日我們的日常生活？「過去」代表今日社會對「不遠的過去」（recent past）認識的總和，有時被媒體稱為「歷史記憶」。以台灣來說，1945年8月15日二次大戰結束後，1947年發生二二八，1949年白色恐怖開始長達四十年。到底，我們如何認識二二八？與白色恐怖又有什麼關係呢？今天的民主自由與歷史經驗有關嗎？藉助圖像又能喚回歷史記憶與當下意識到民主自由有關嗎？

歷史學者溫蒂・科佐爾（Wendy Kozol）寫道：「跨國人權見證必須面對凝視的政治，不是為了找到現成的理解，而是要認識到觀看的視覺行為中的道德和奇觀的互動。」我們從這樣的說法得到啟發，全球當代社會正處於「再現過去」影像的謹慎時刻。電影與攝影的大眾媒介特質，帶給了今天的台灣民眾視覺的「道德和奇觀的互動」，面對第一階段法治體系轉型正義運作的尾聲，台灣過去的歷史經驗從來沒有如此「凝視政治」的機會，我們是否以為：過去已經過去了？

這本攝影作品集為您正在「凝視」過去而見證！

2022年3月

《流麻溝十五號》作者

參考文獻：〈Complicities of Witnessing in Joe Sacco's Palestine〉，Wendy Kozol。

火燒島

流麻溝15號

我在綠島時，努力拍攝著不是「劇照」的劇照，試圖重塑五〇年代老政治犯所說的牢獄模樣，希望藉由這部電影的拍攝，能重塑當年火燒島上的情景，我想像自己就站在白色恐怖時代的綠島，企圖拍下那些當年不被看見的真相，那些火燒島上的血與淚。

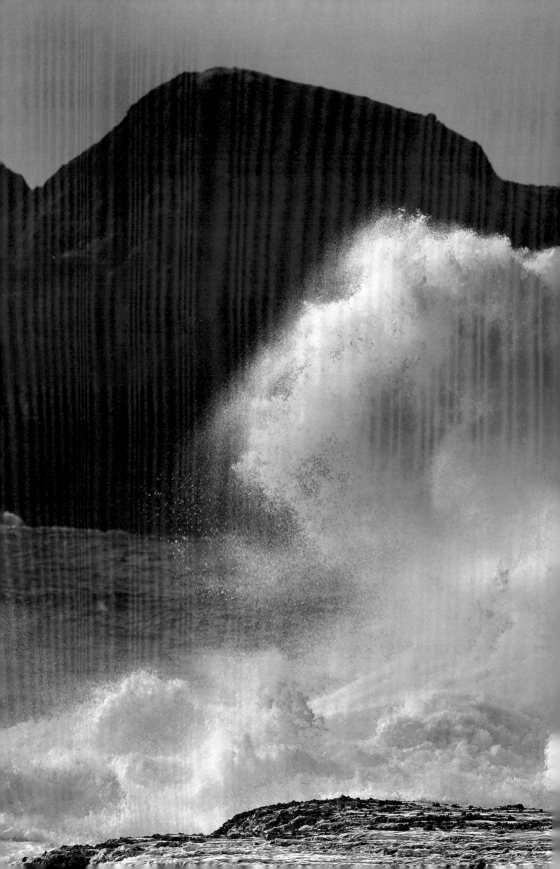

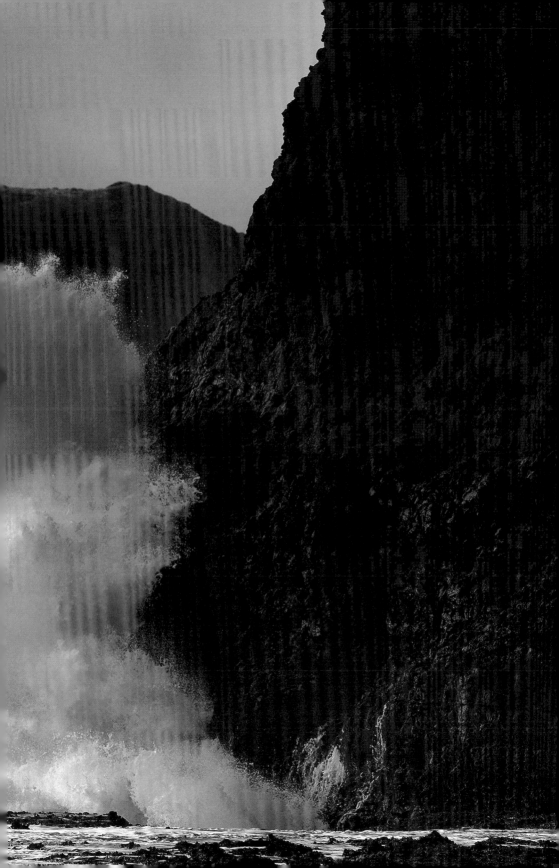

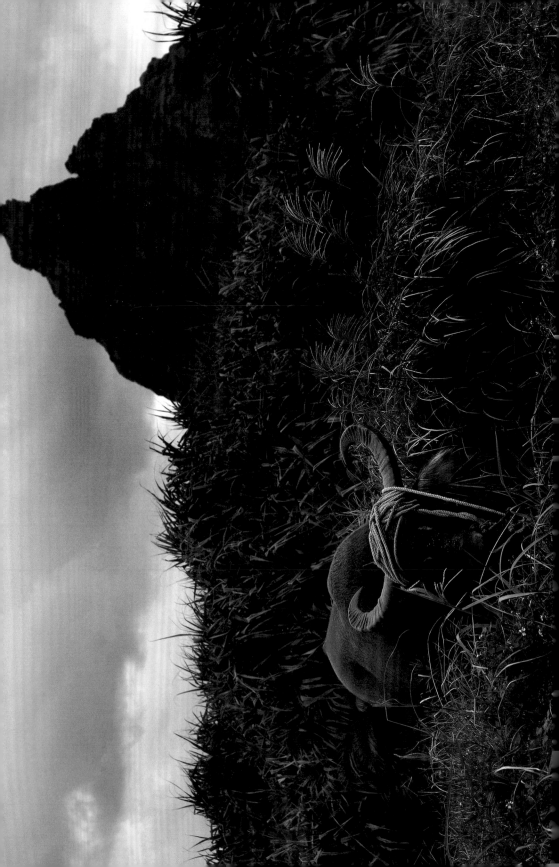

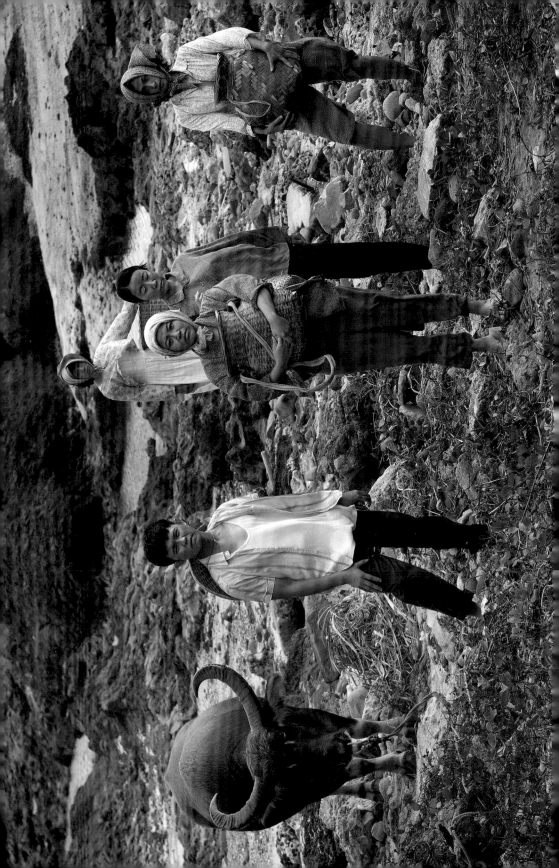

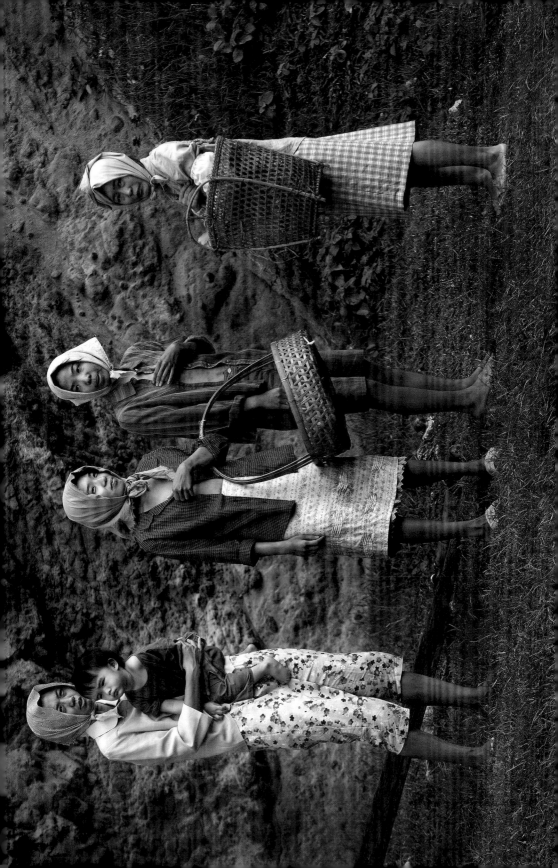

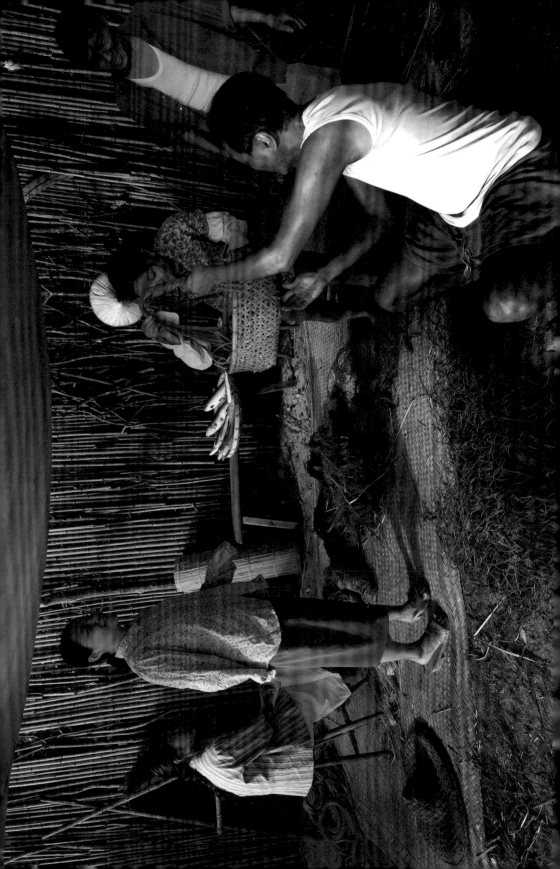

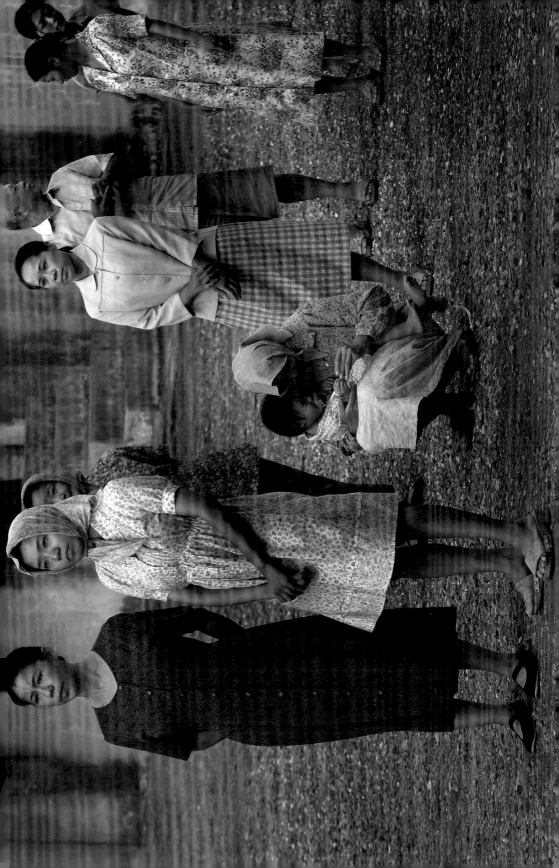

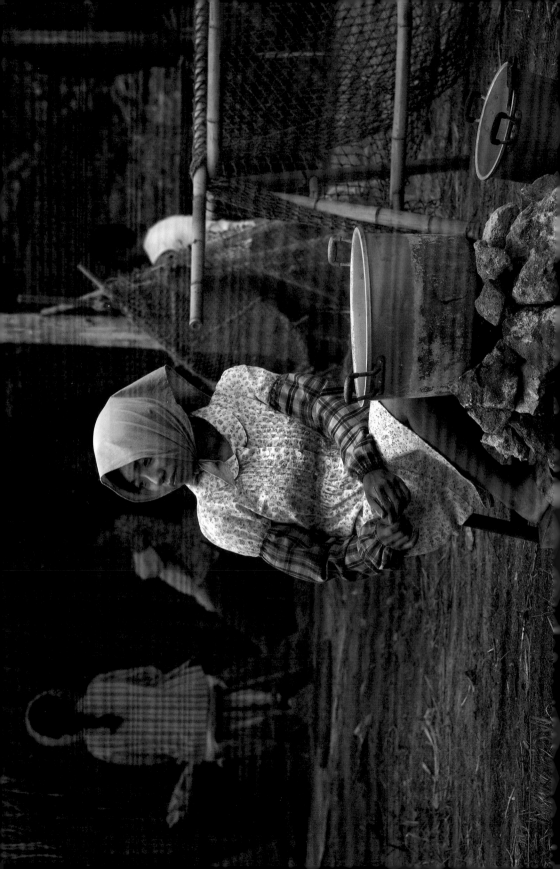

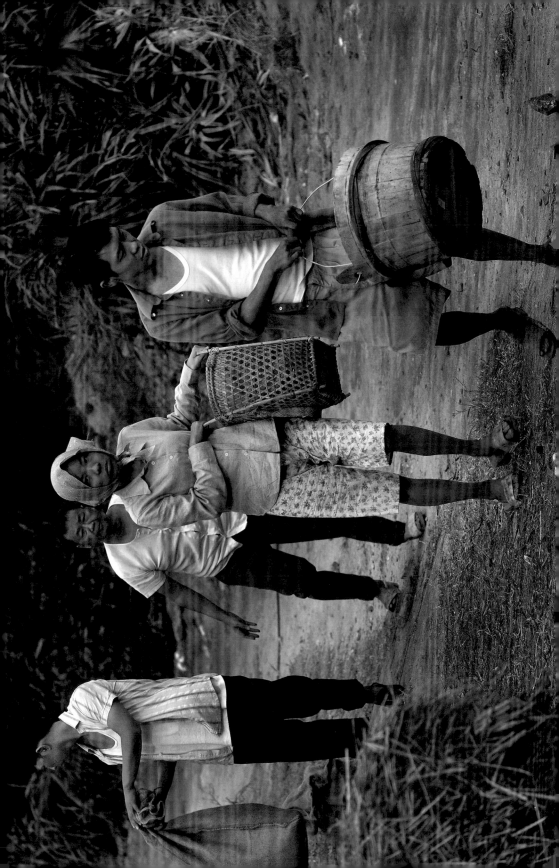

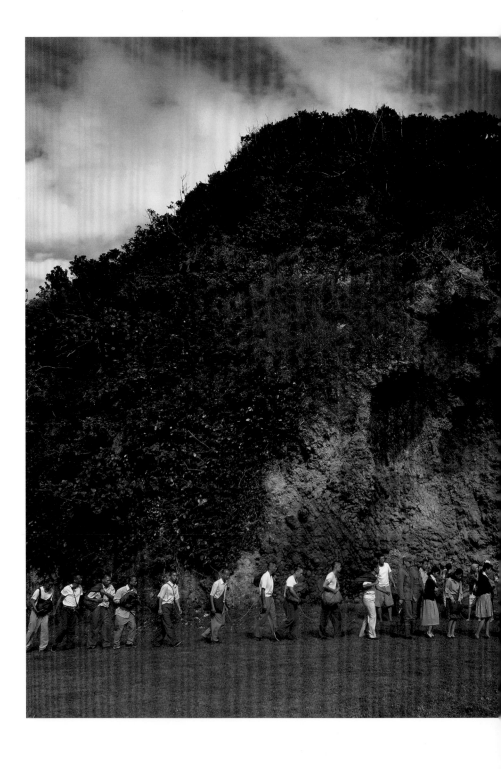

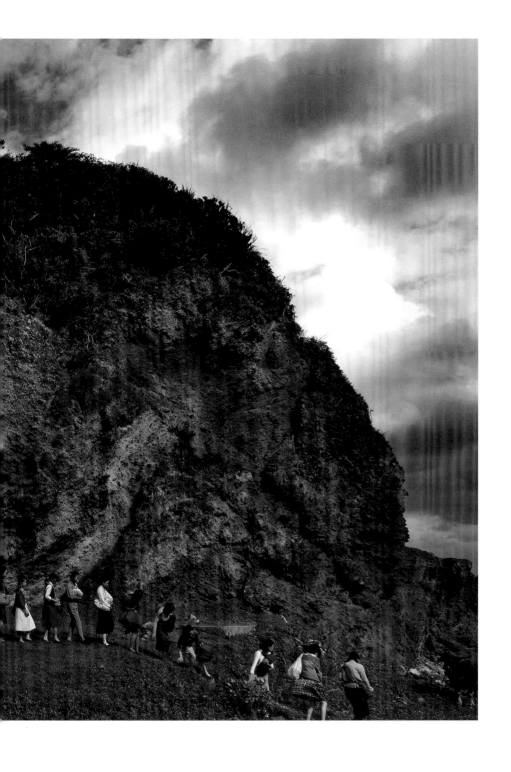

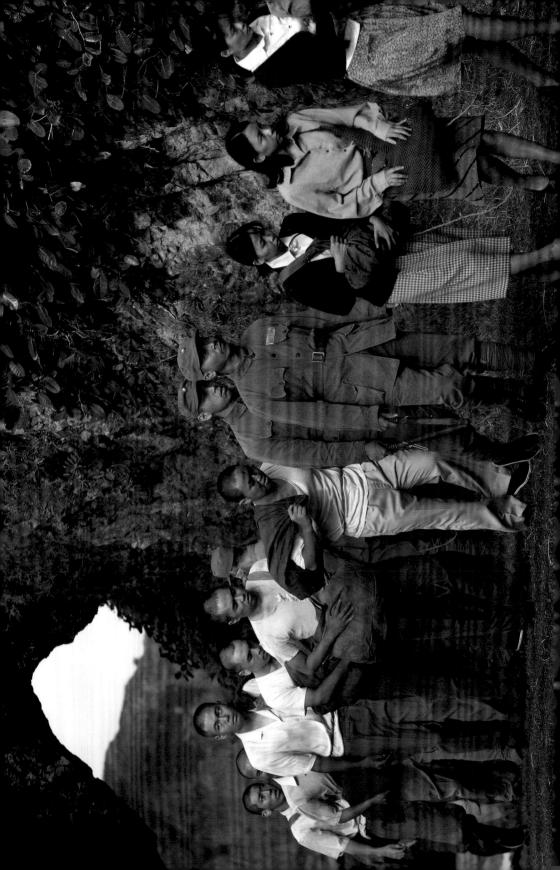

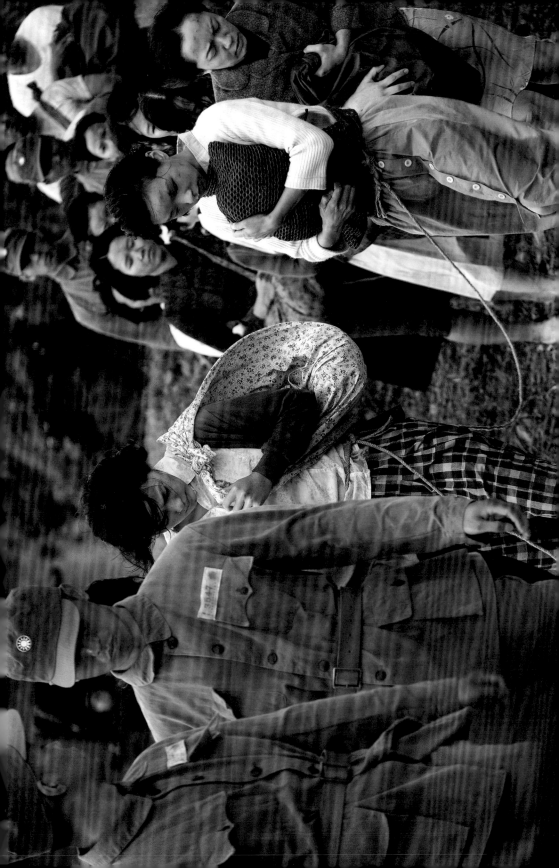

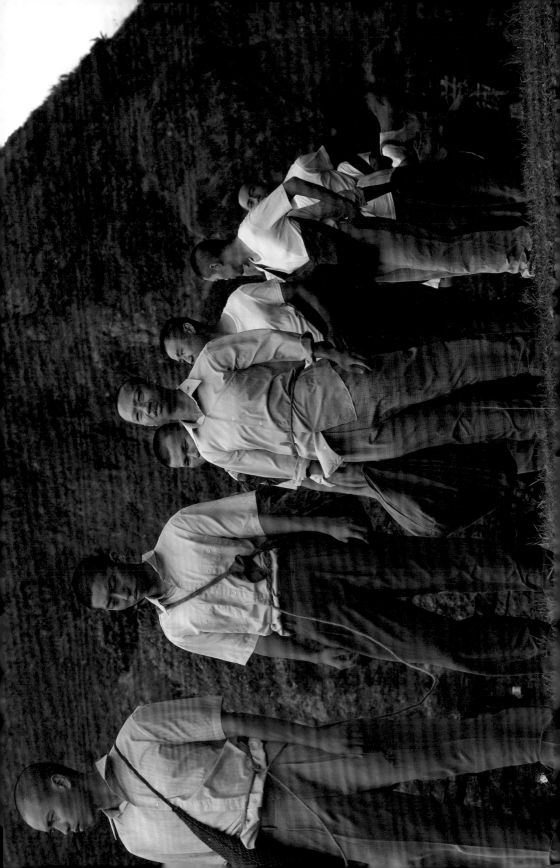

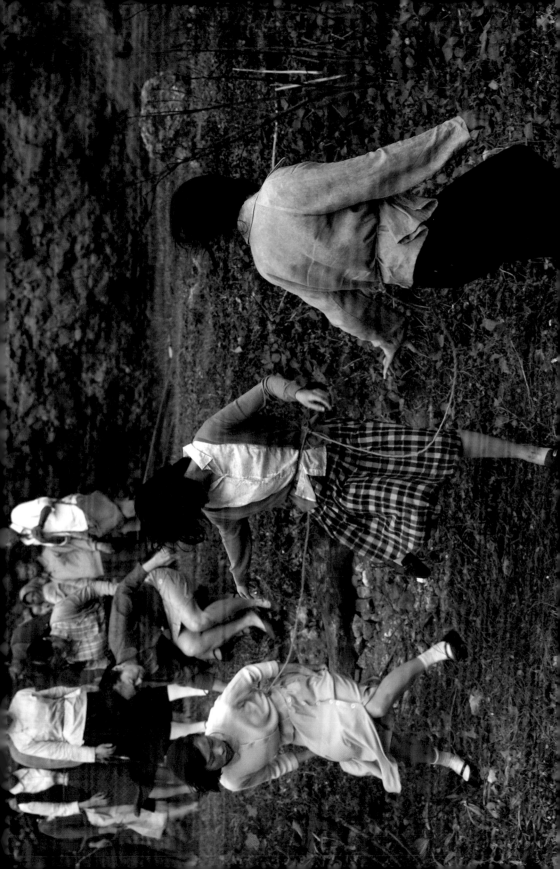

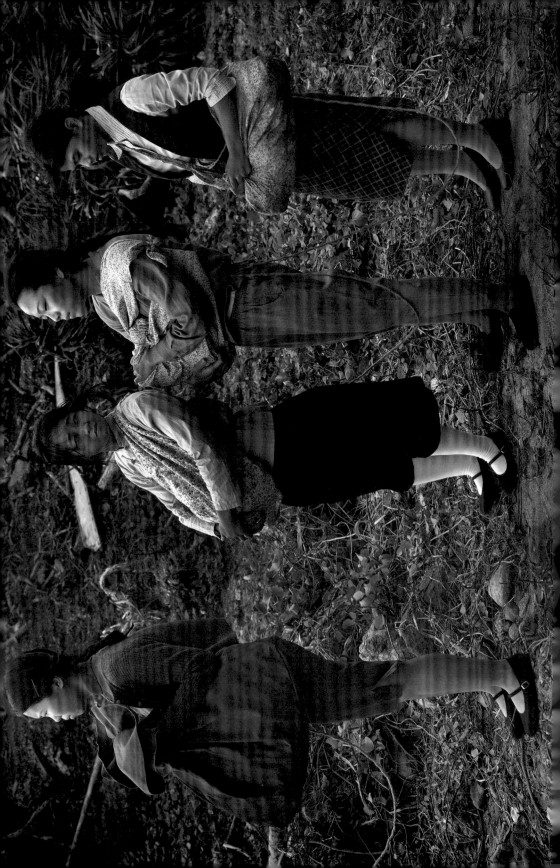

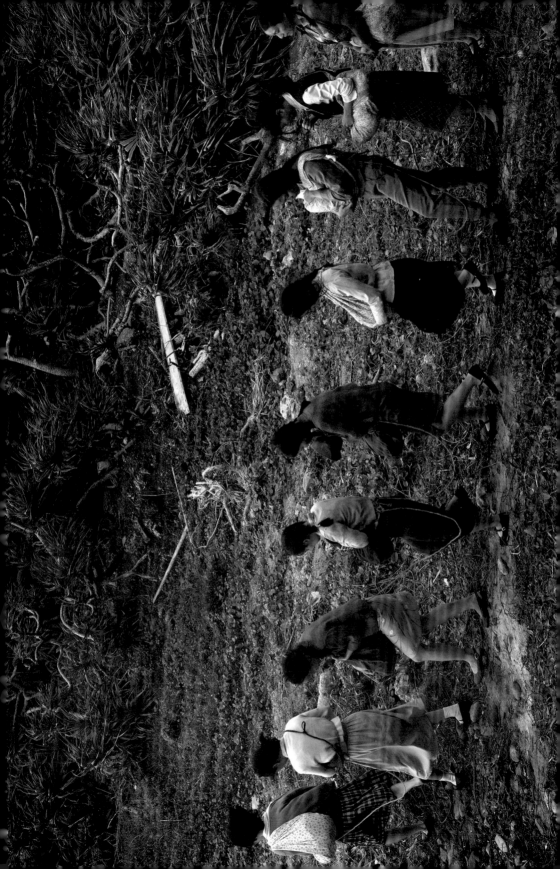

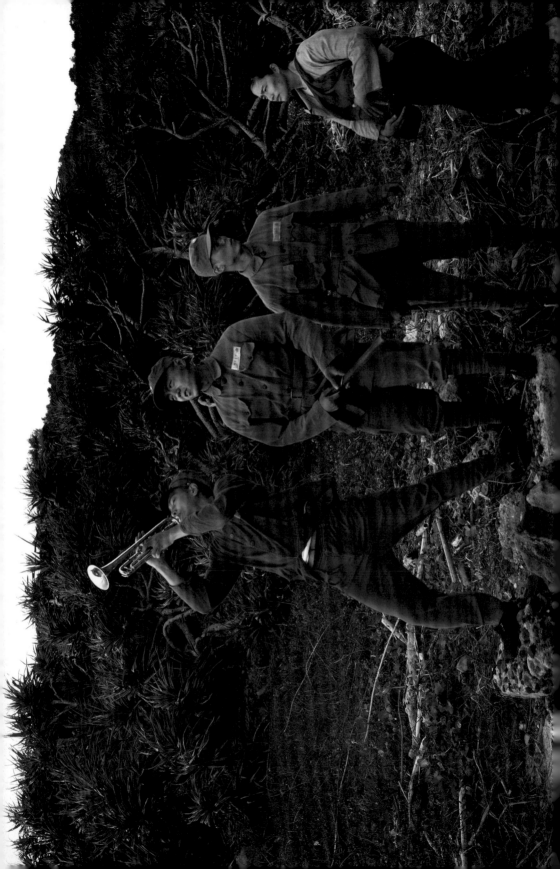

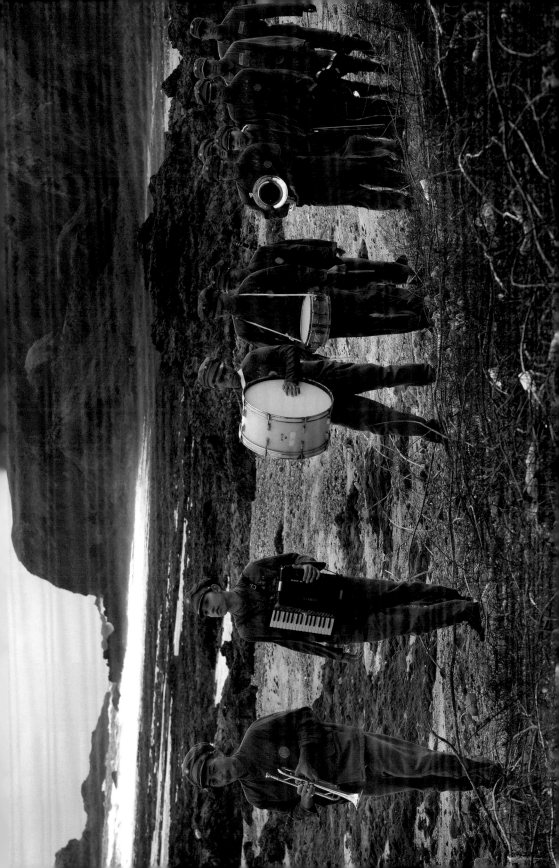

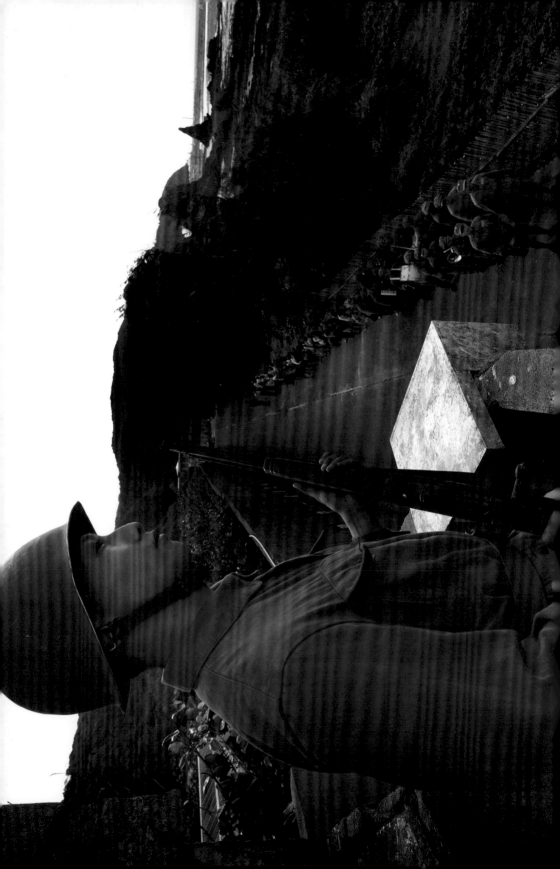

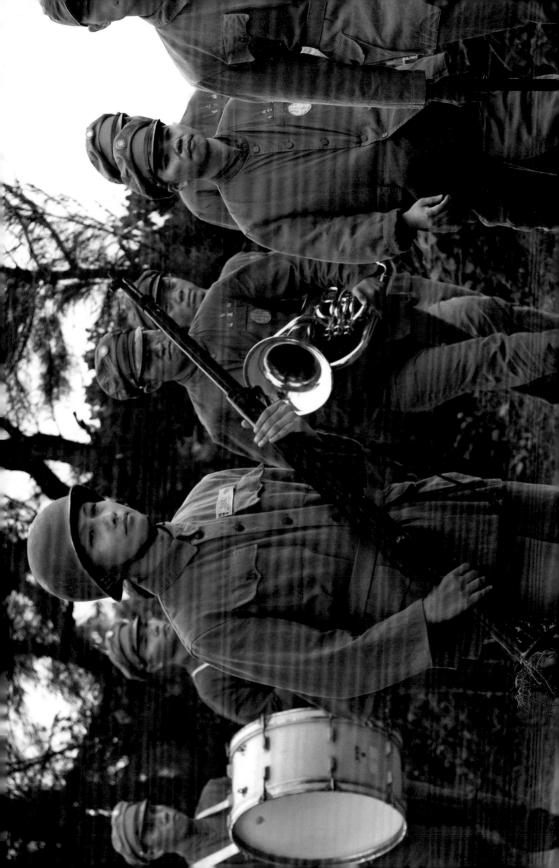

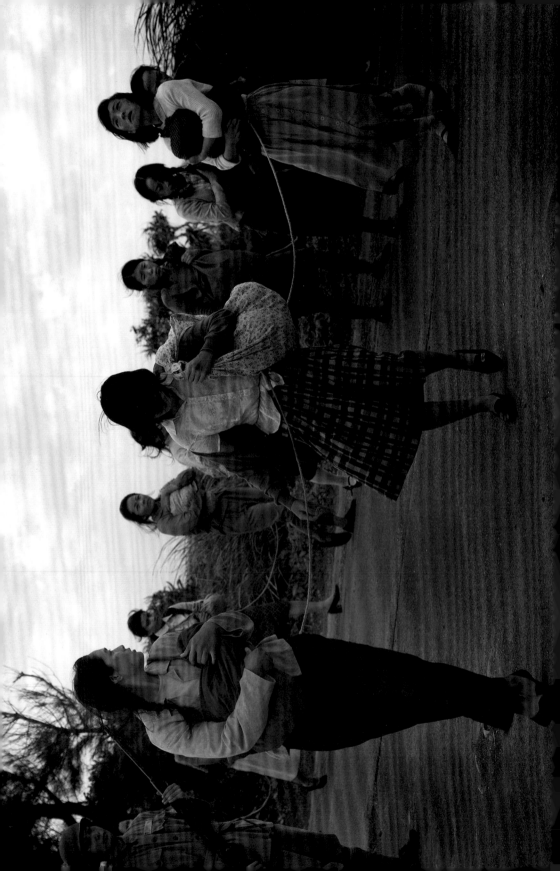

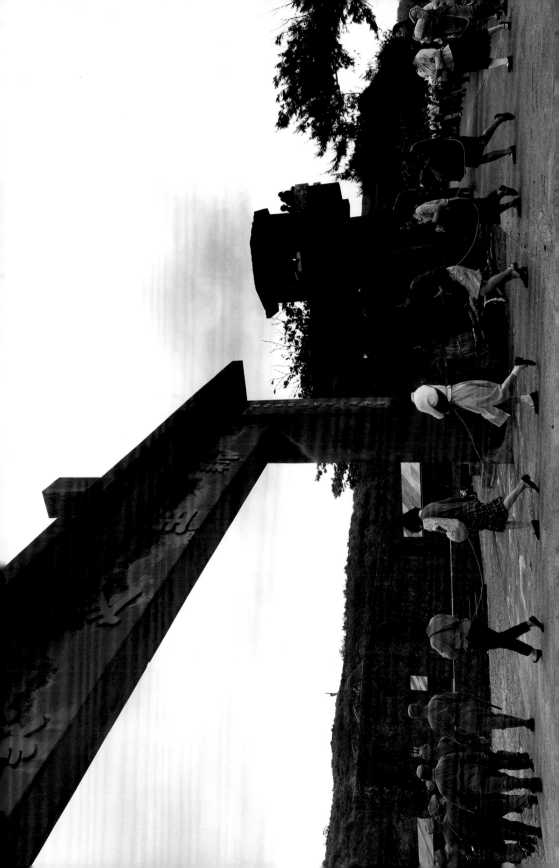

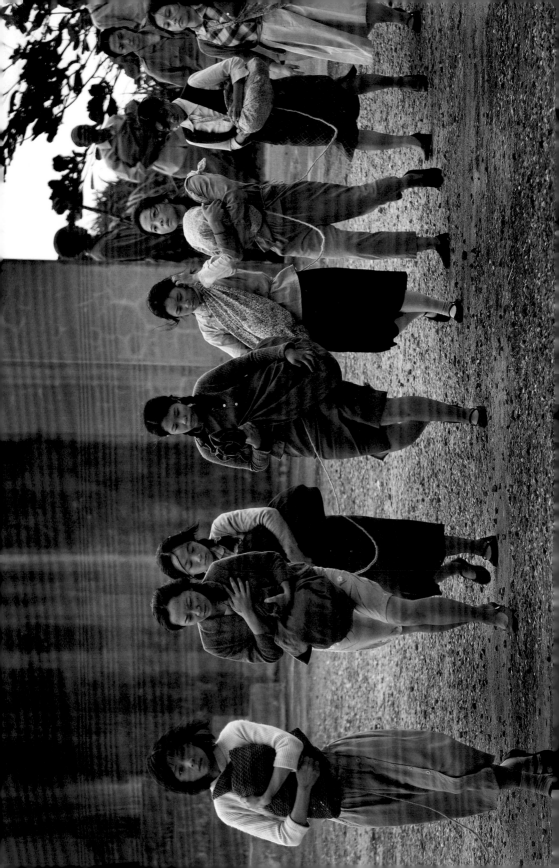

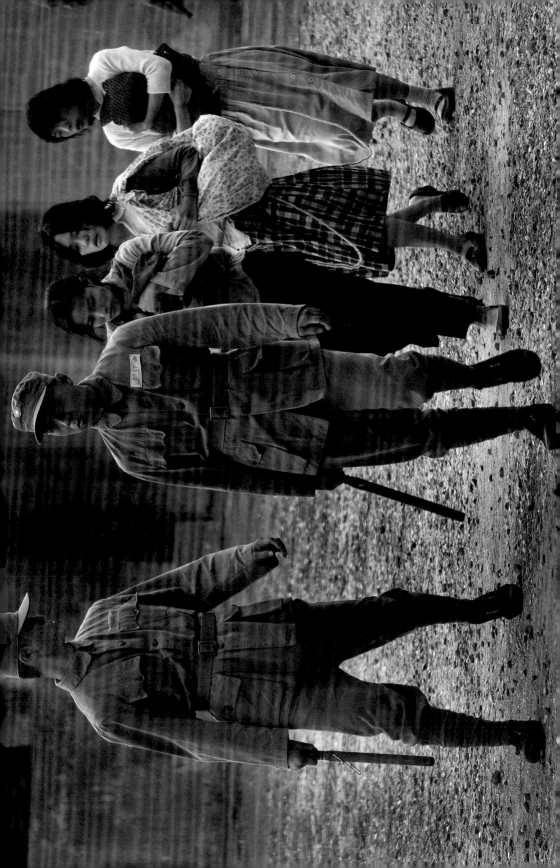

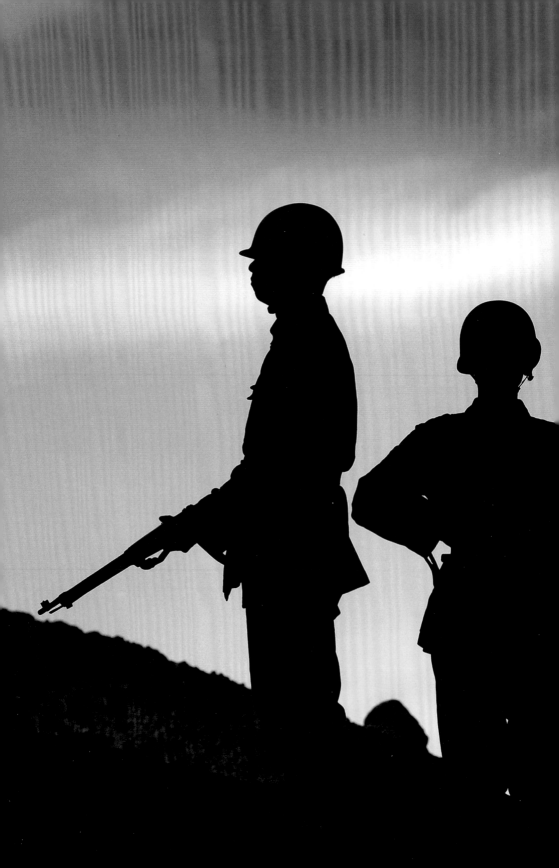

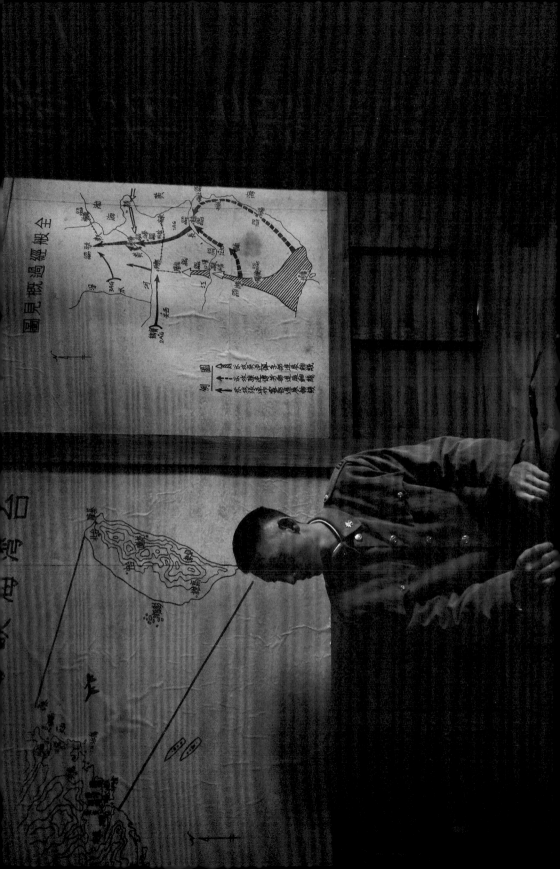

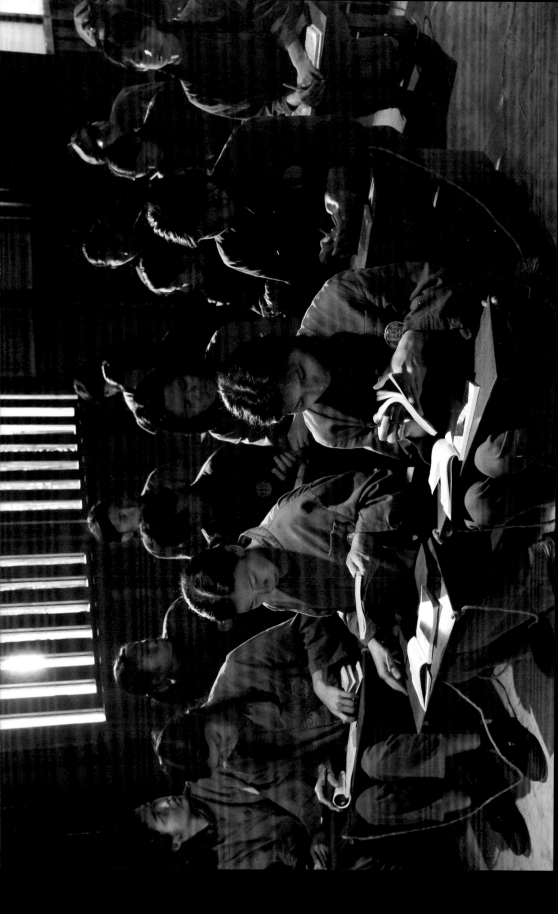

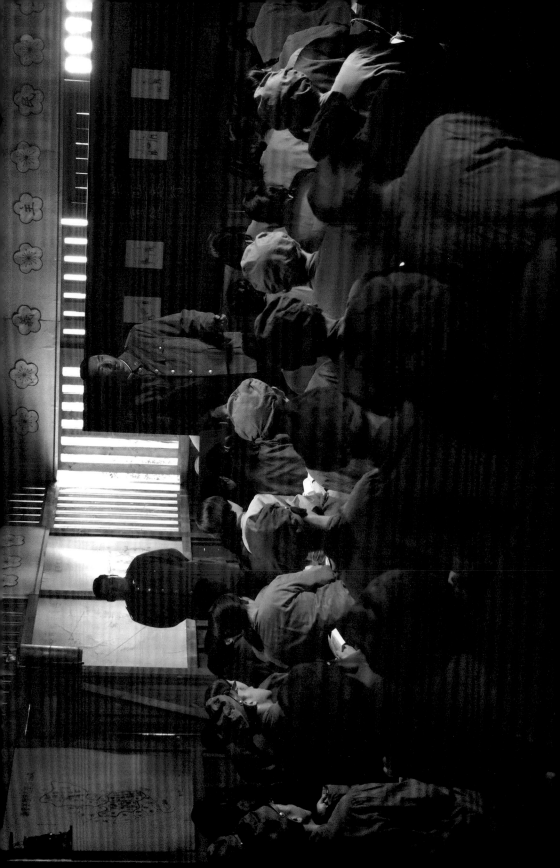

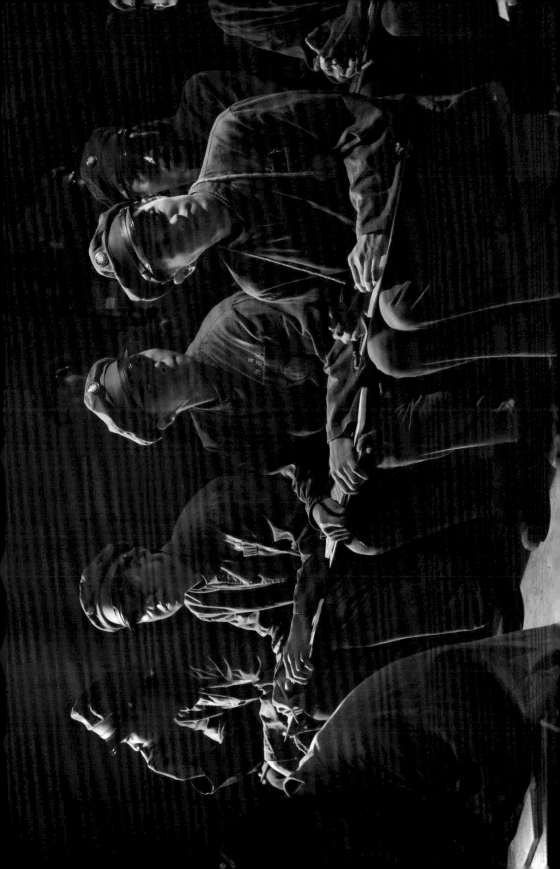

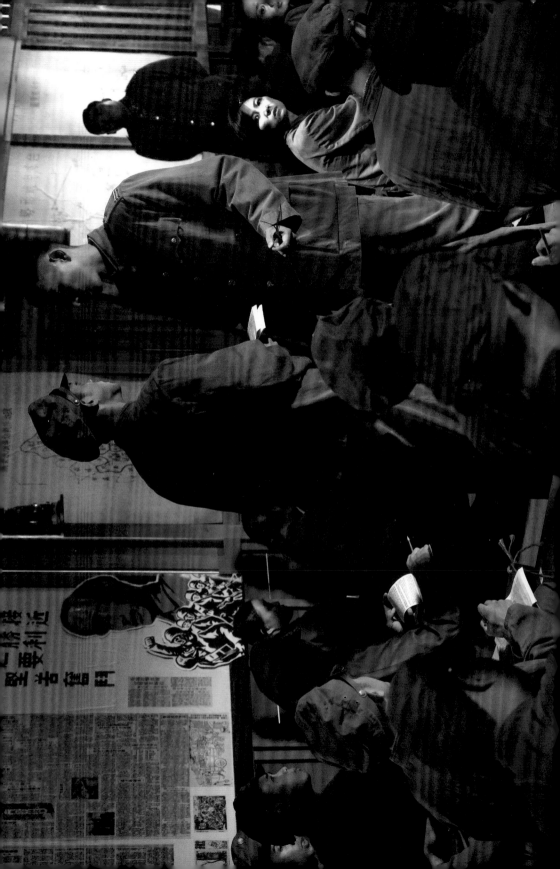

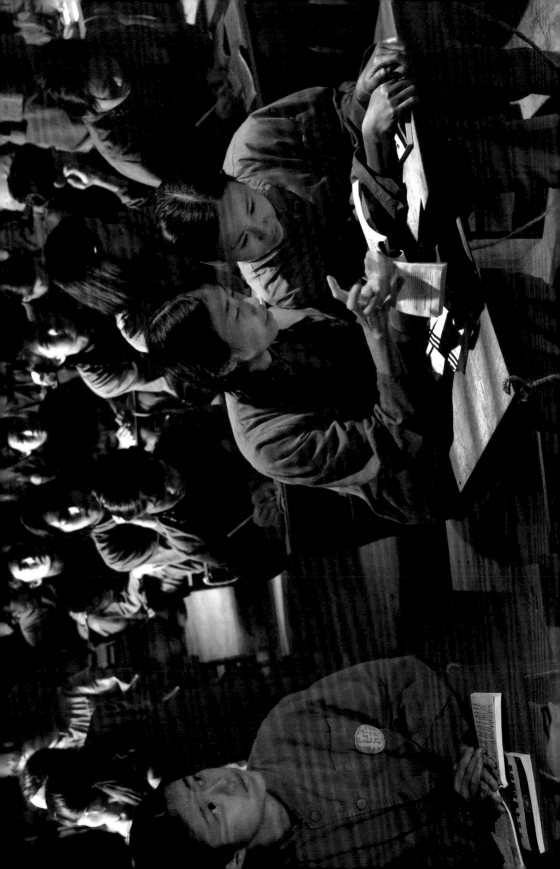

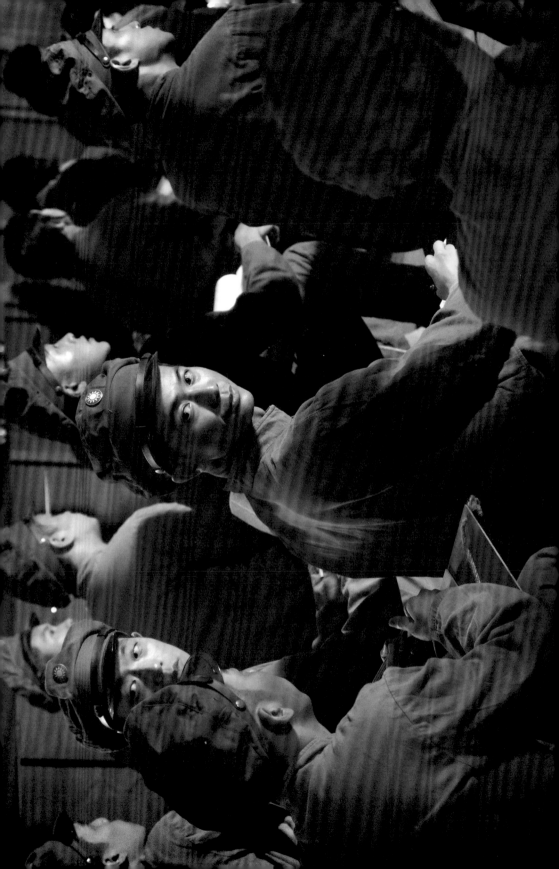

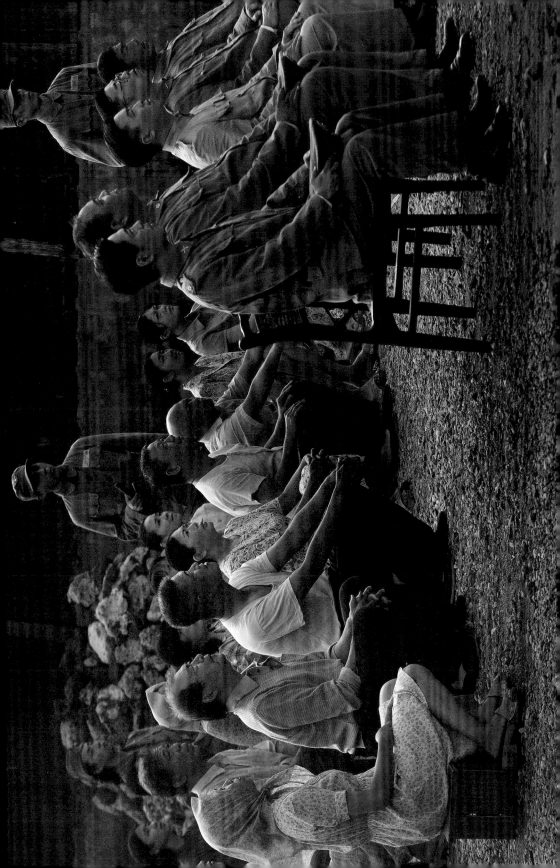

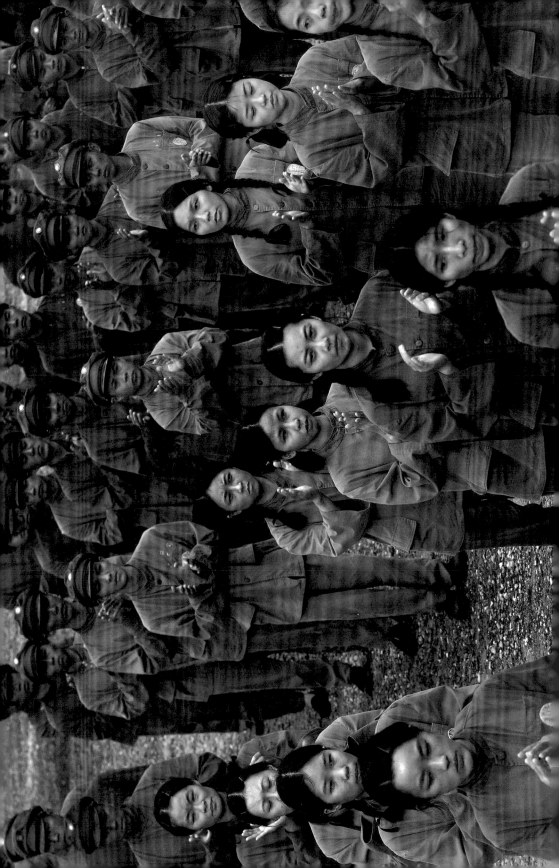

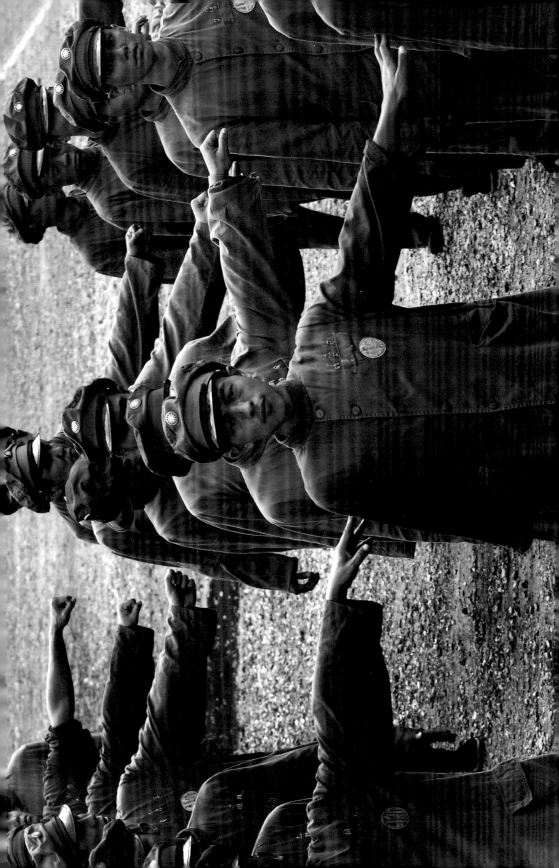

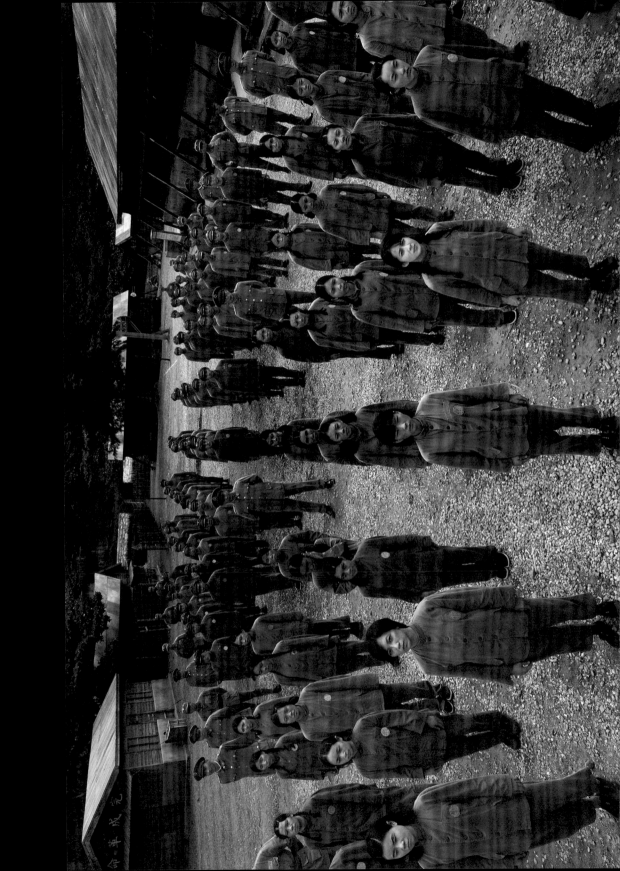

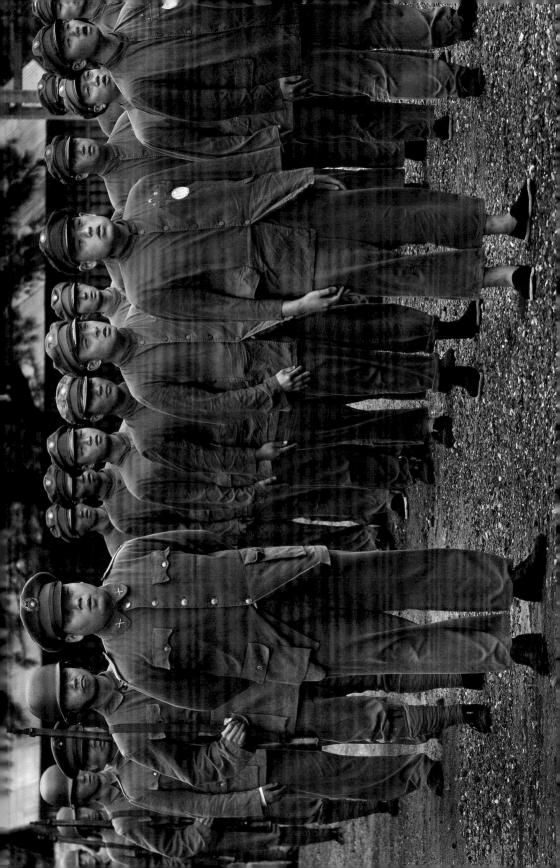

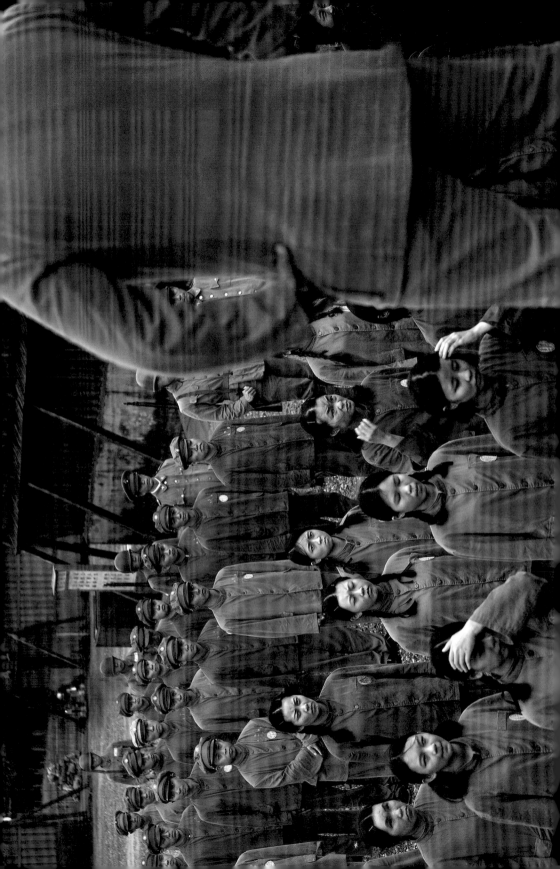

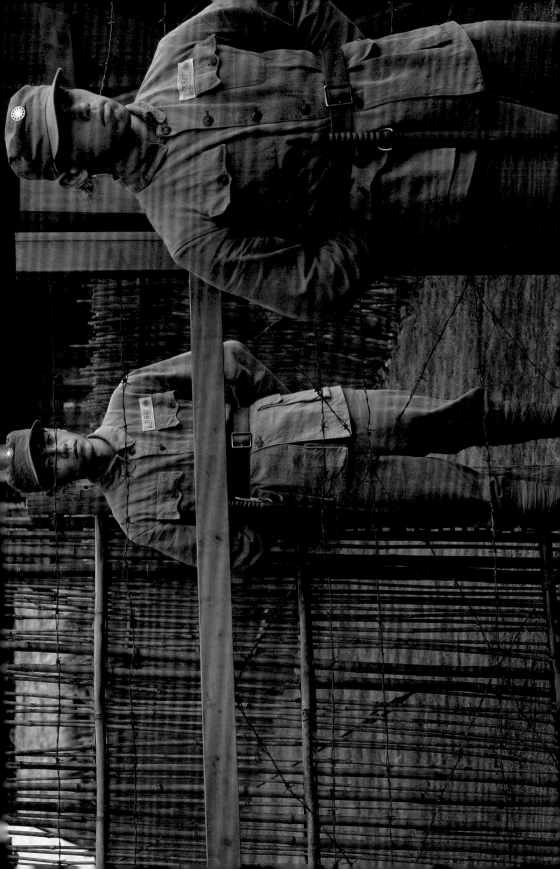

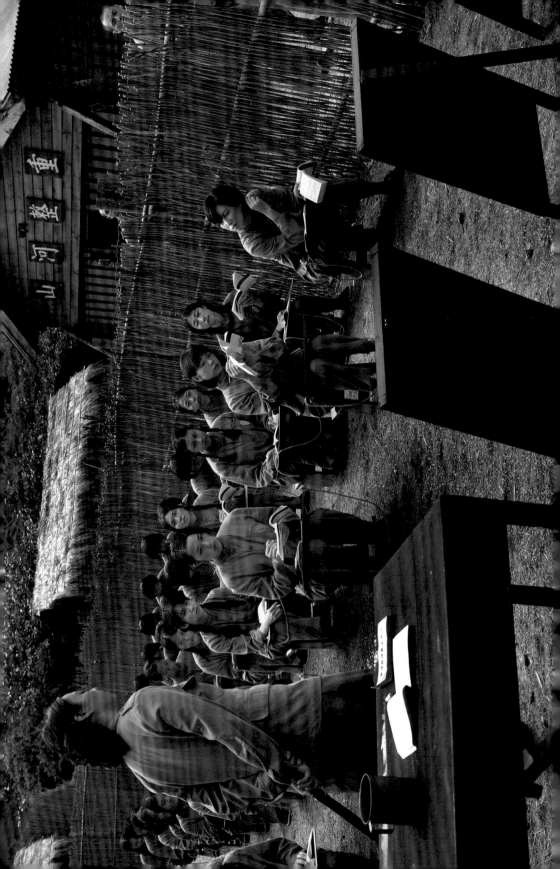

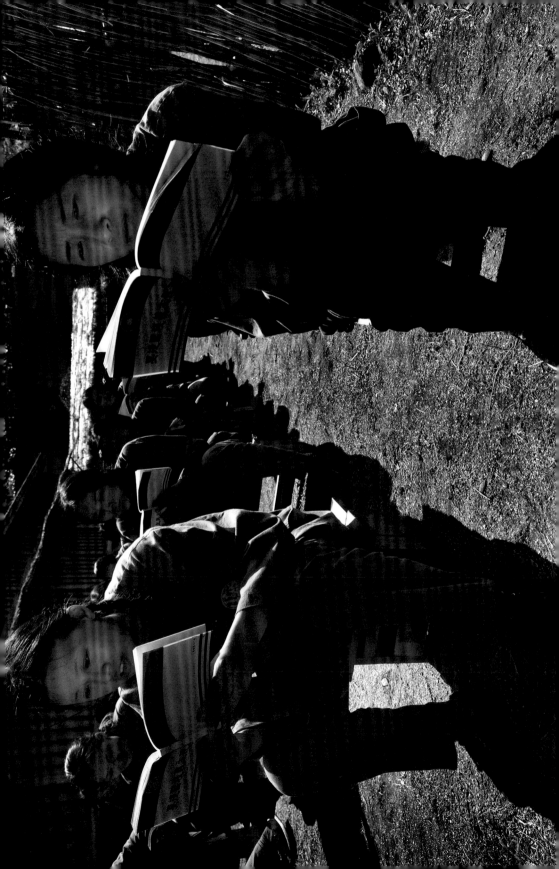

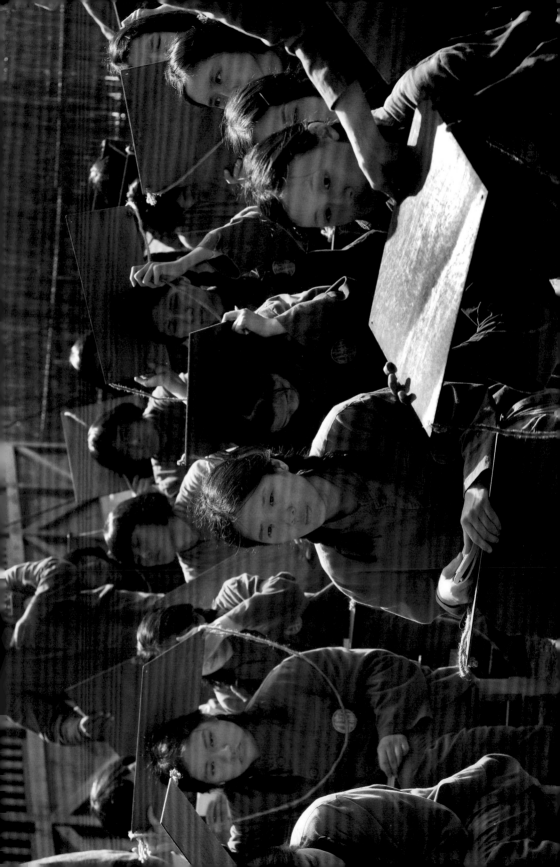

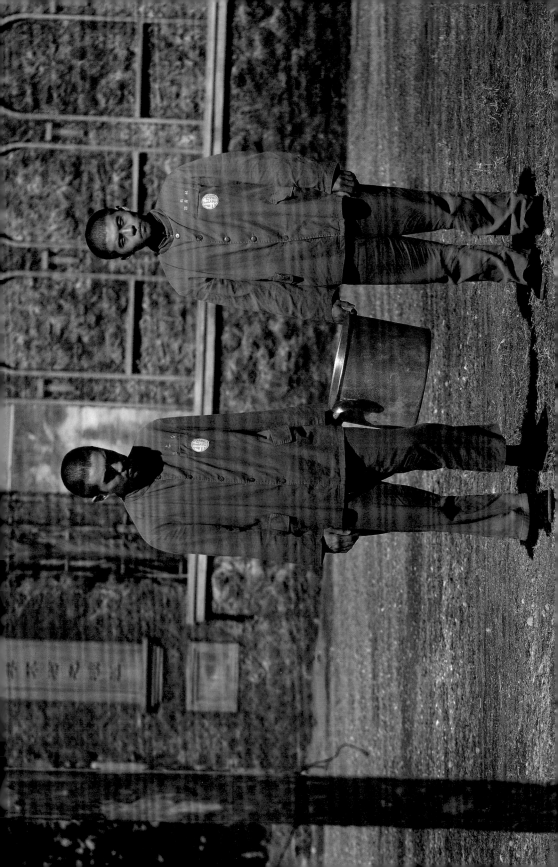

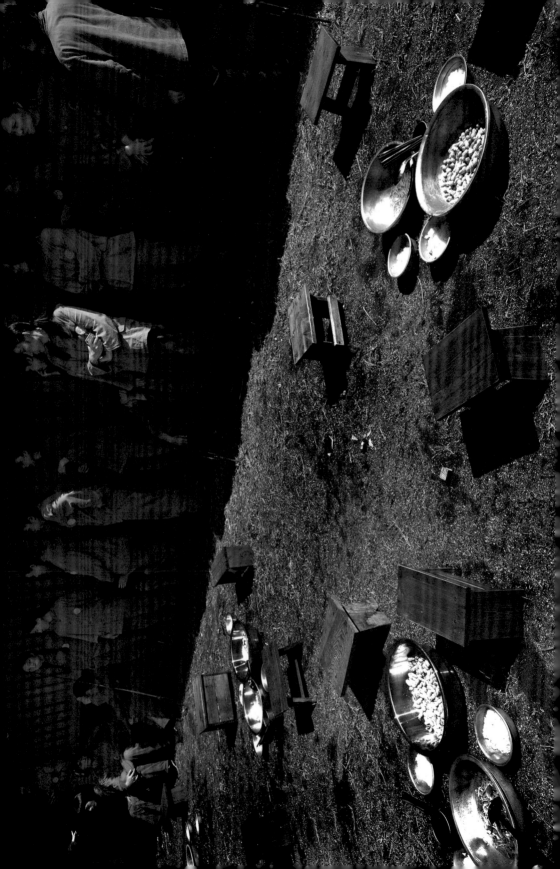

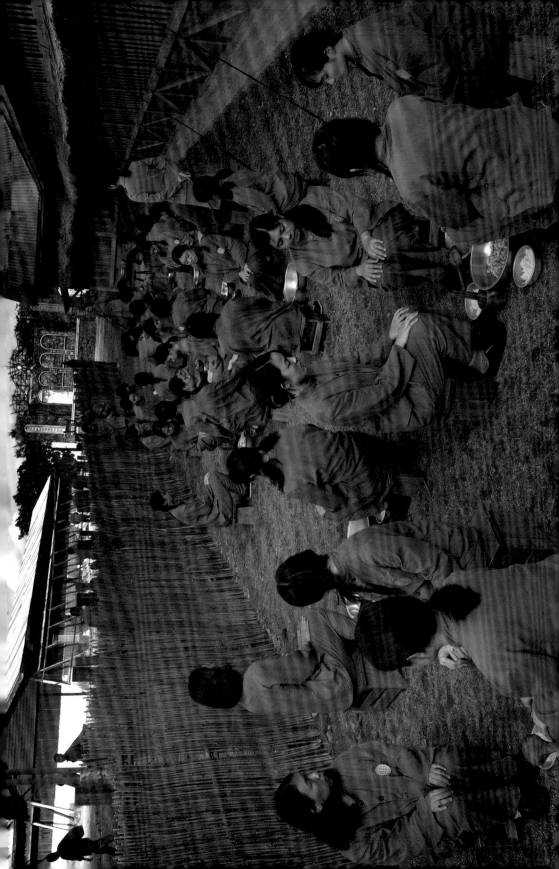

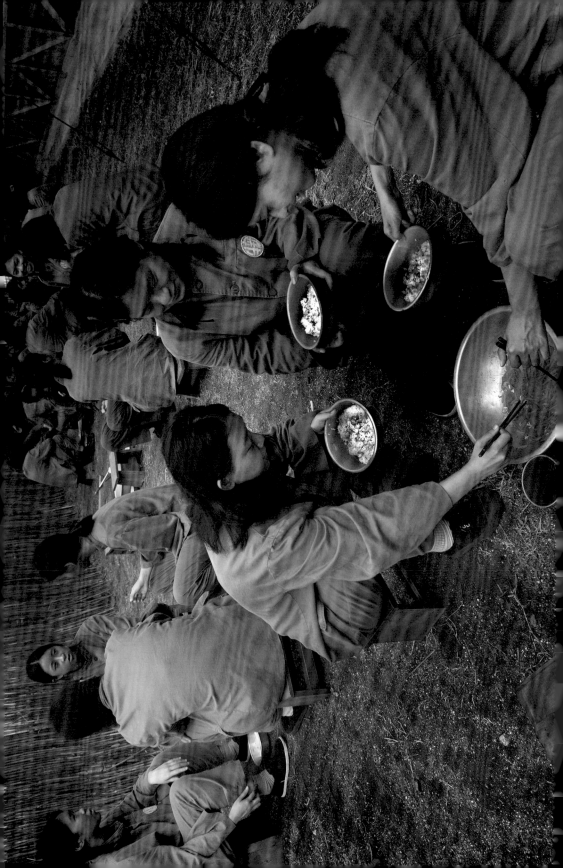

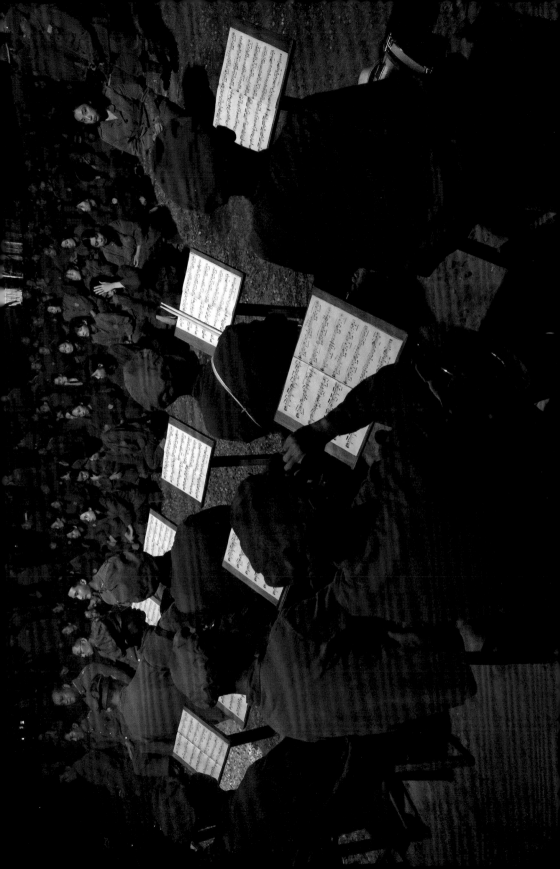

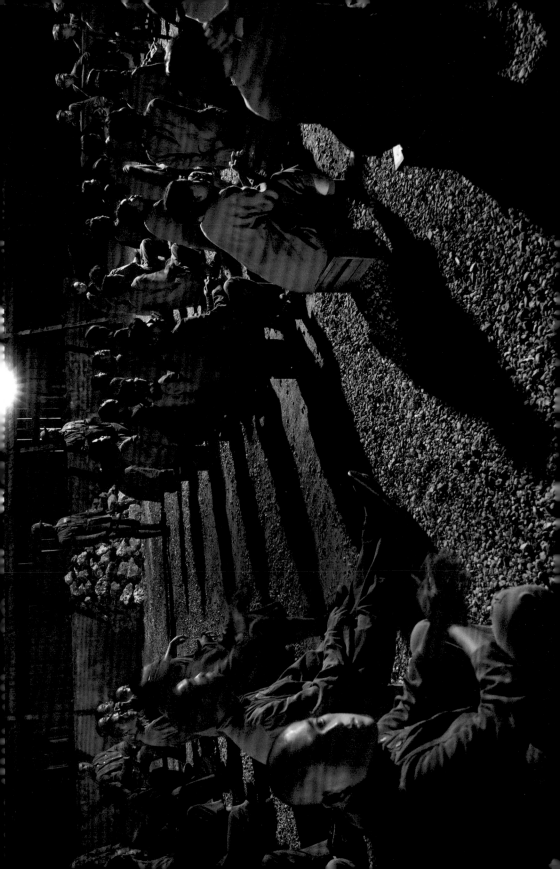

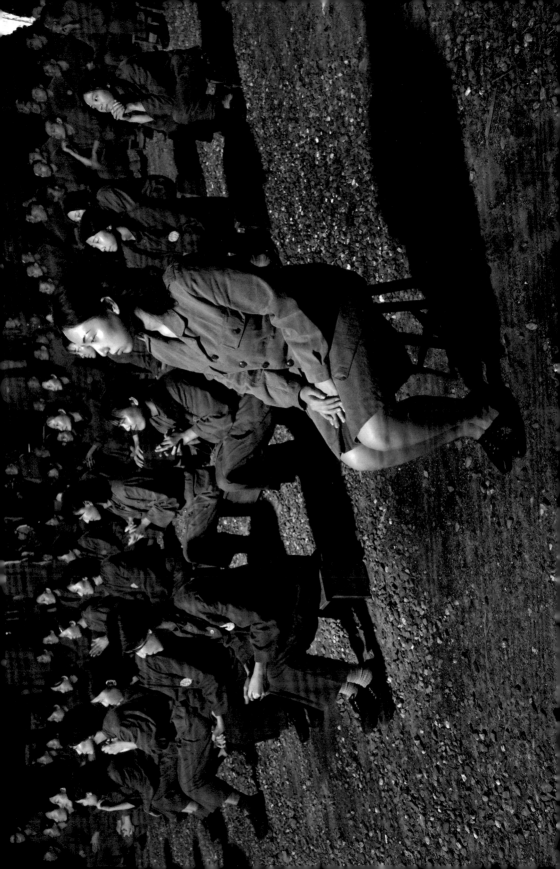

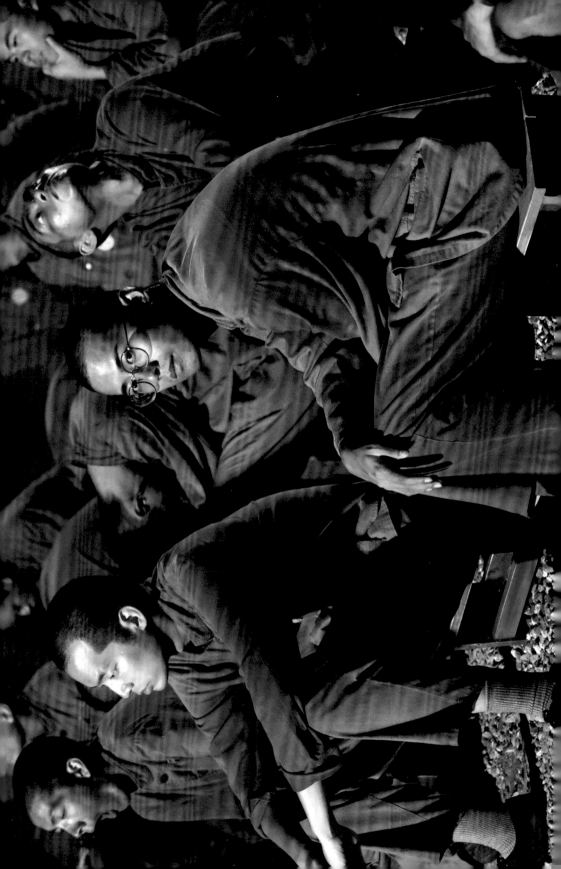

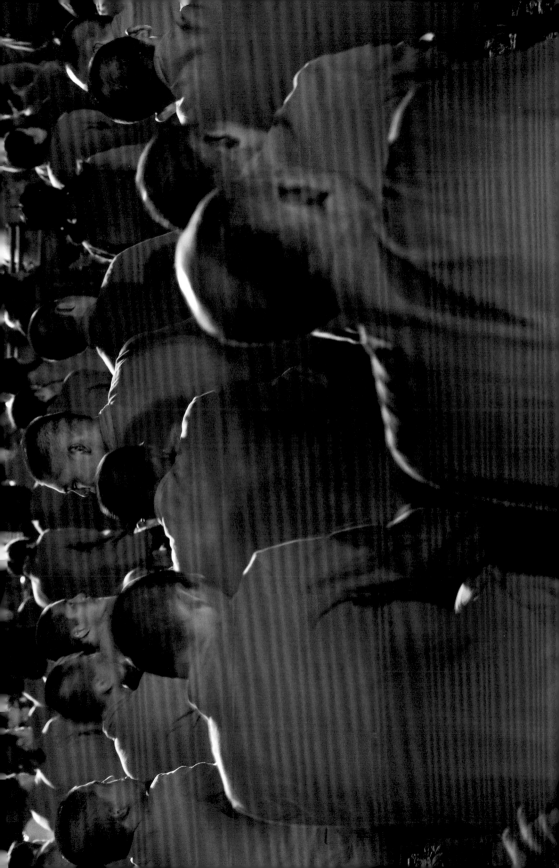

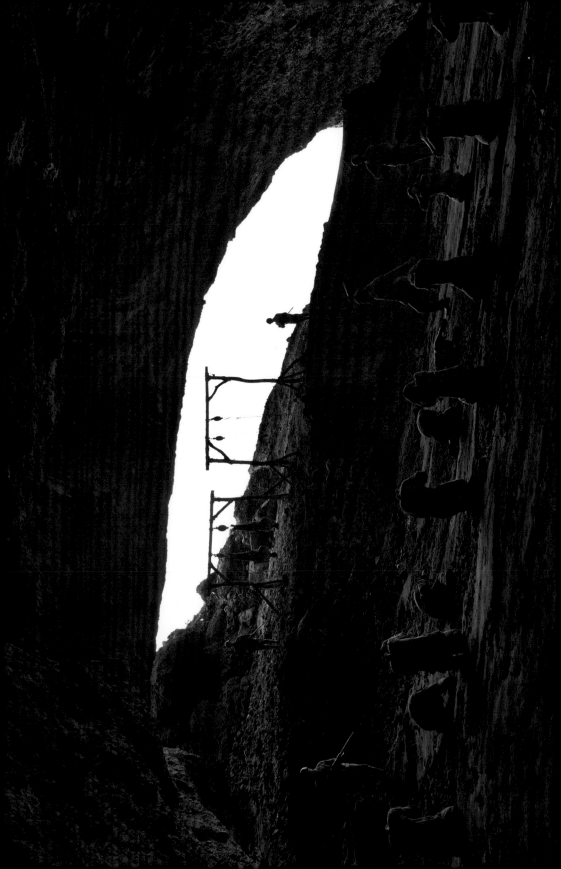

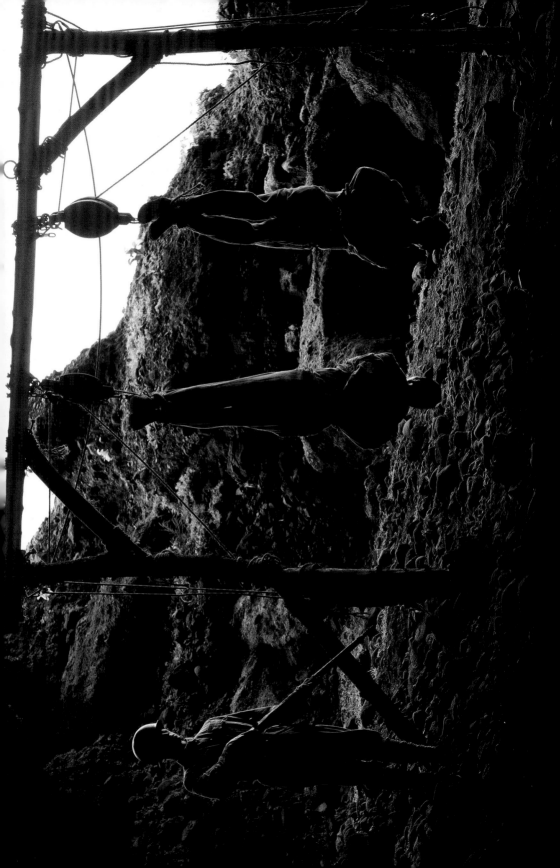

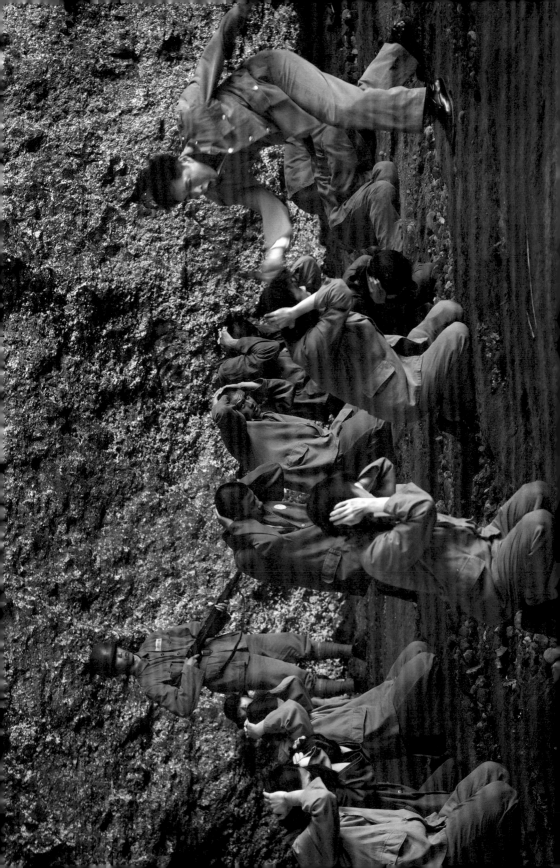

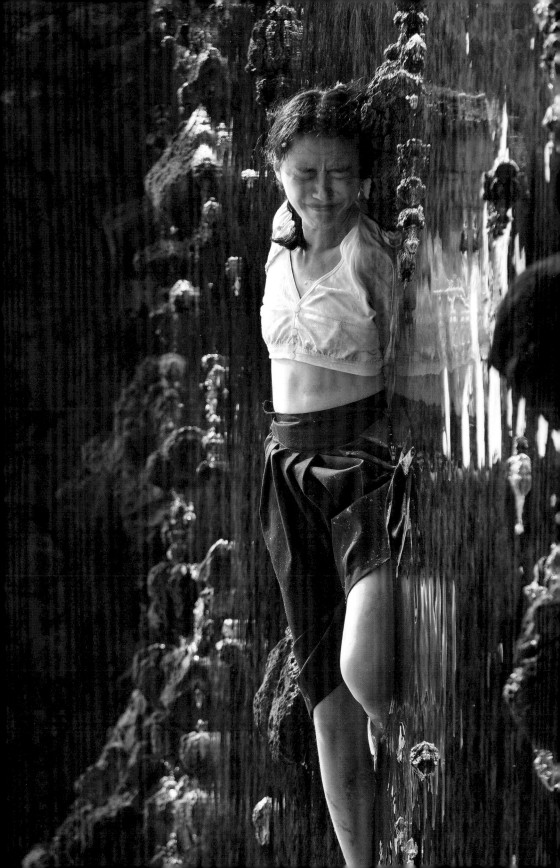

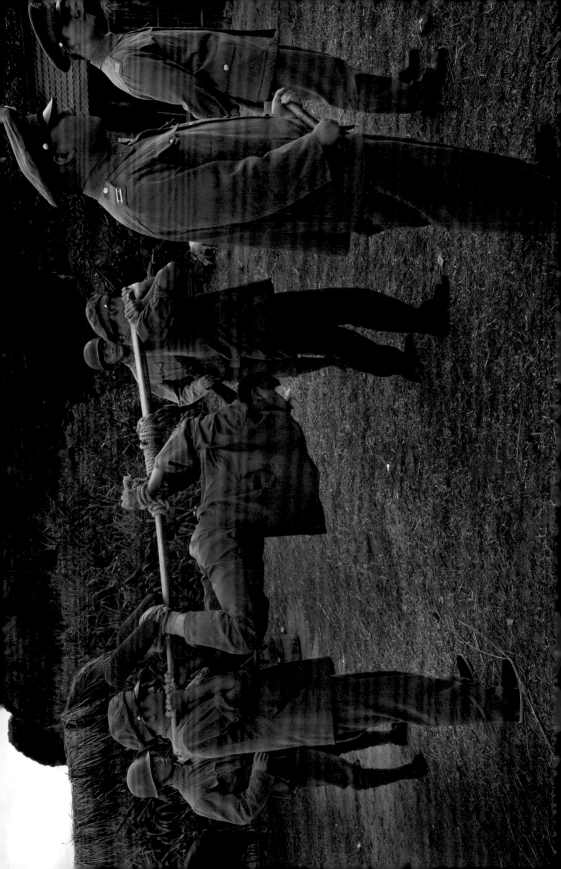

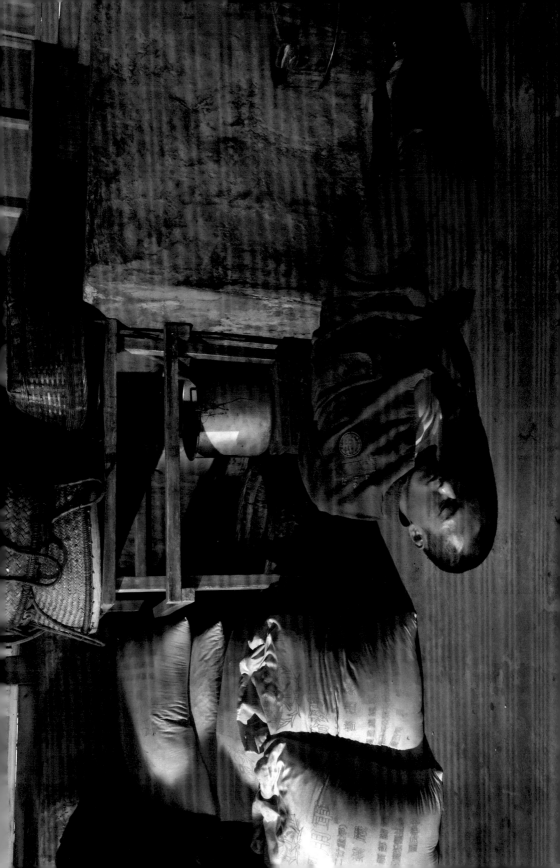

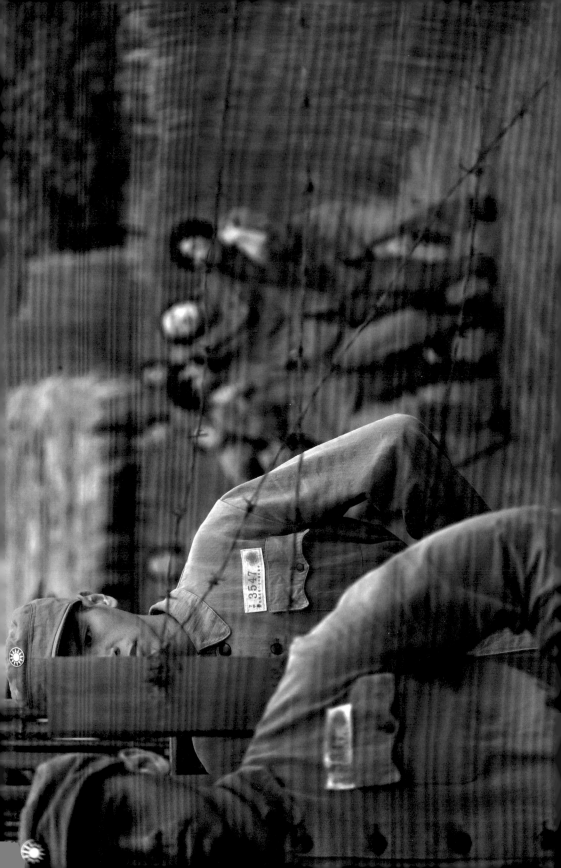

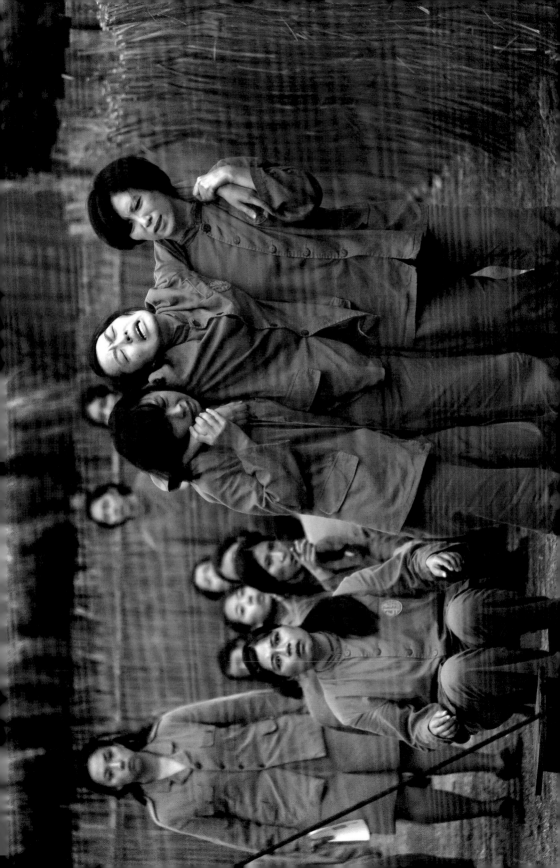

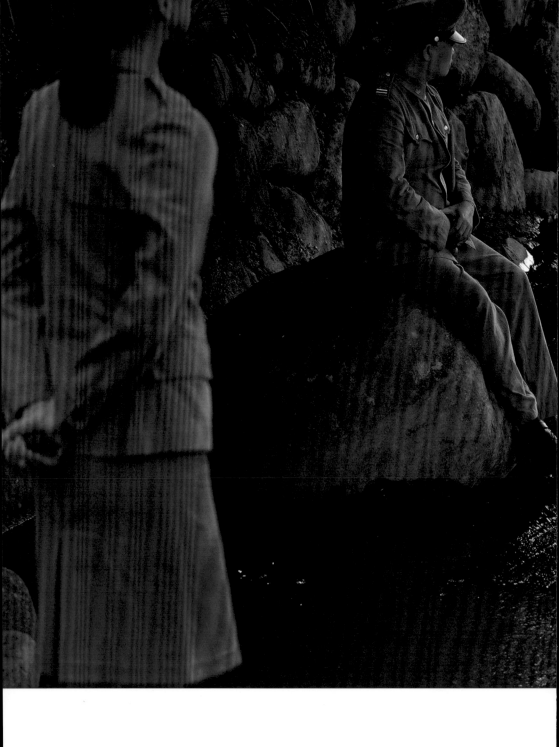

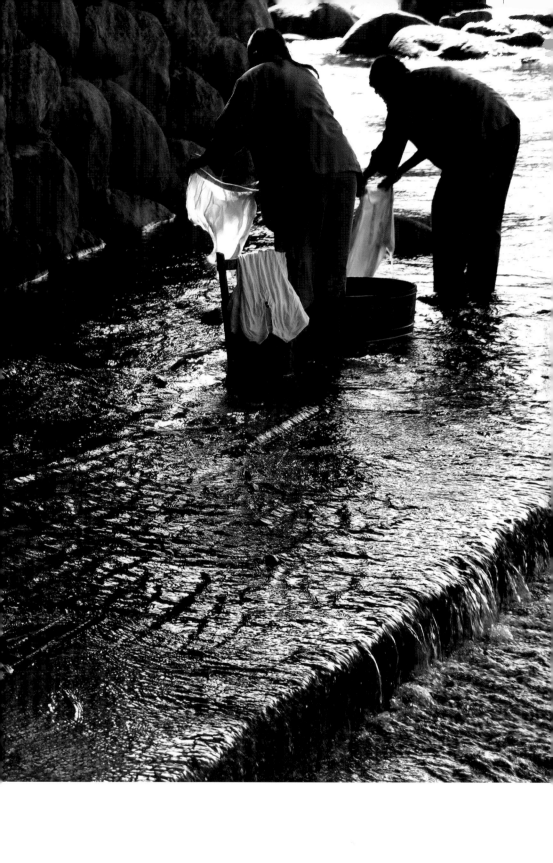

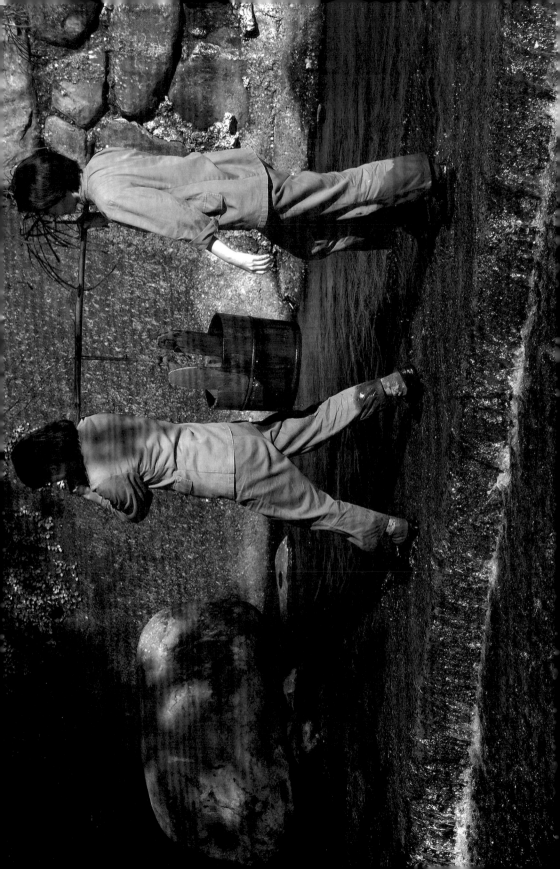

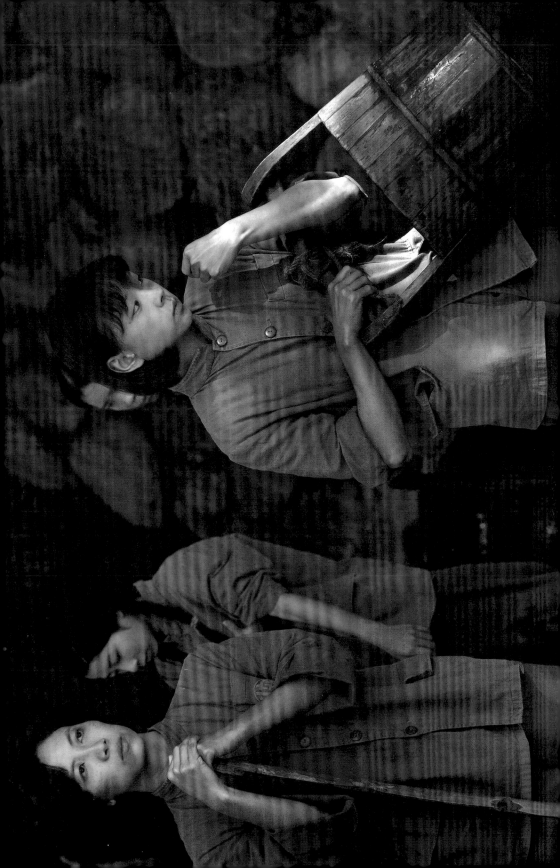

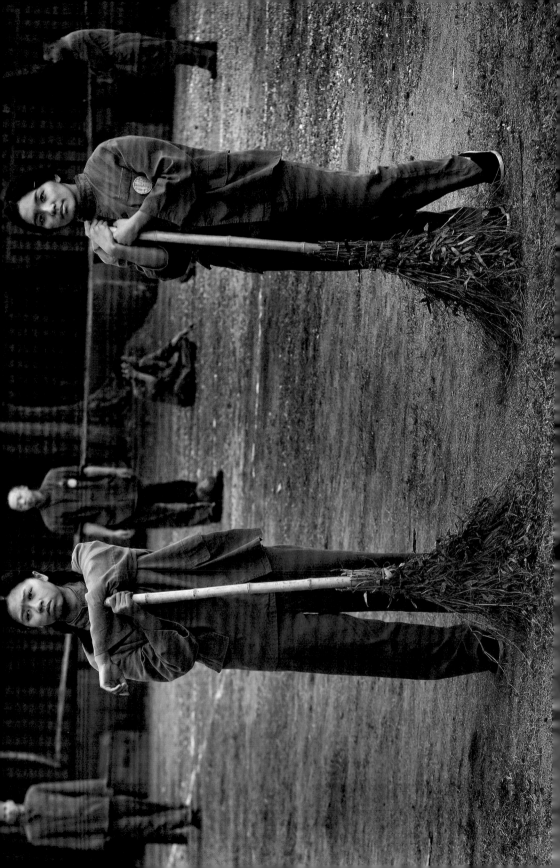

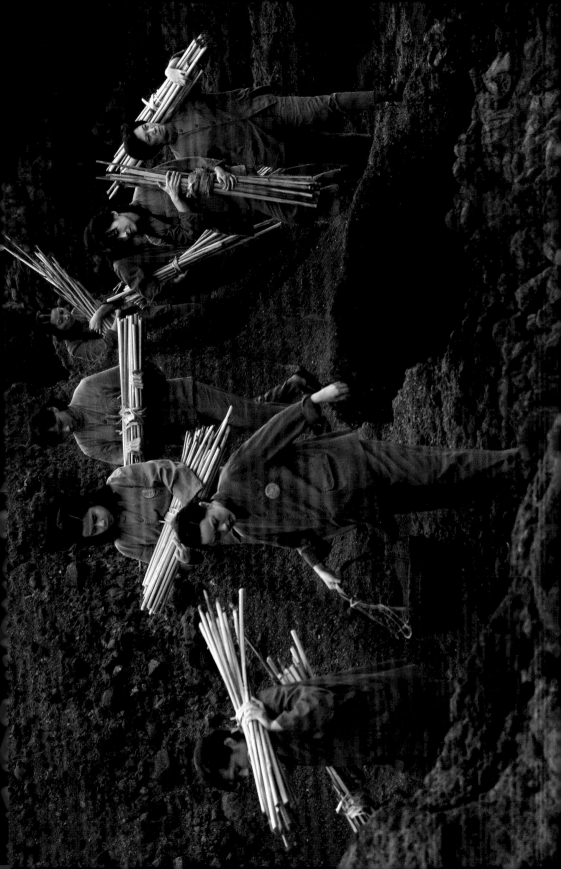

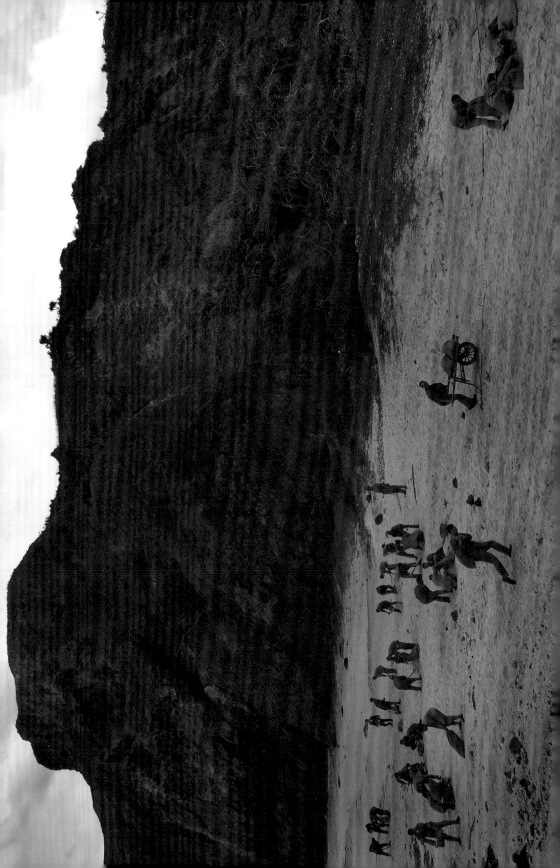

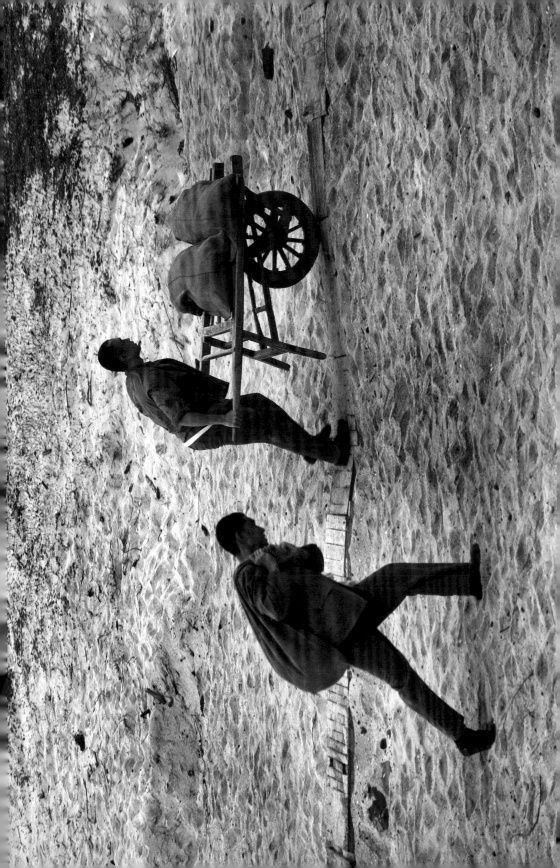

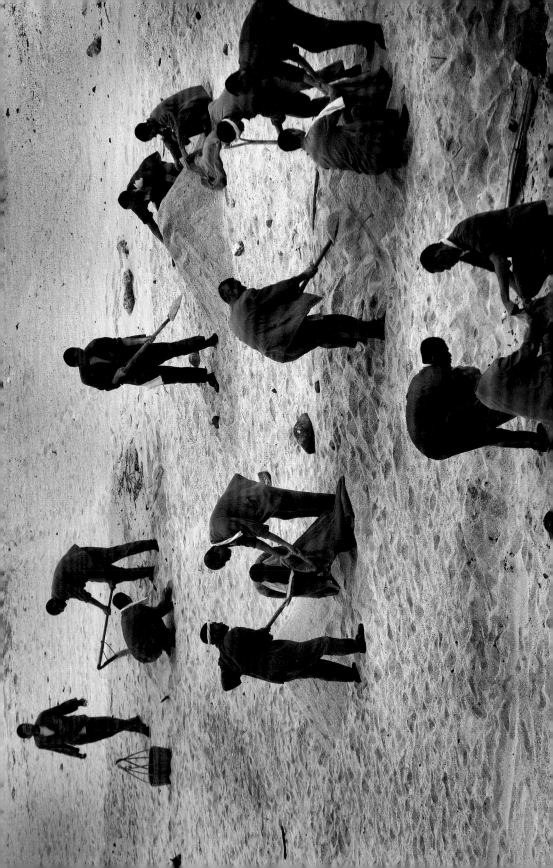

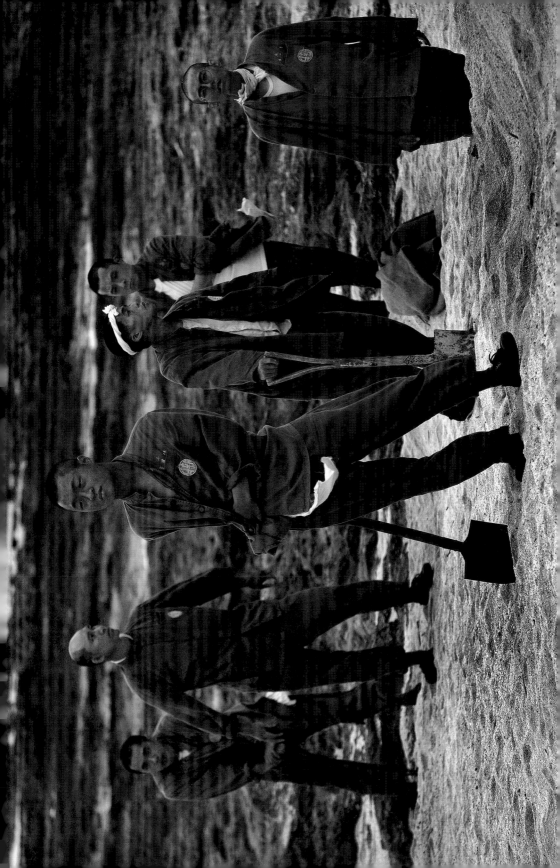

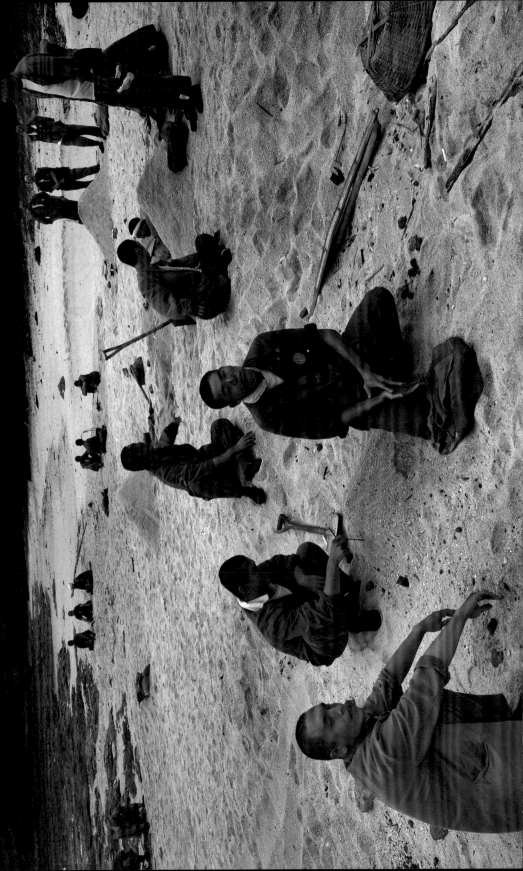

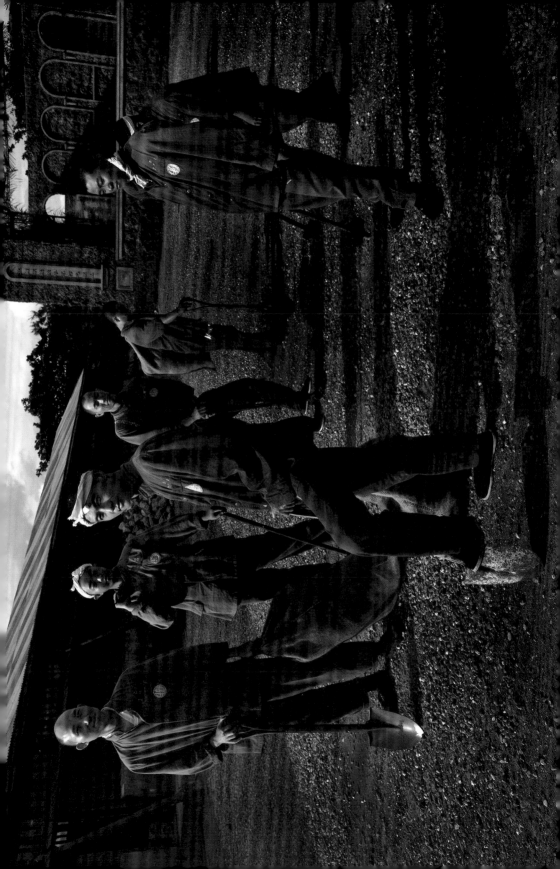

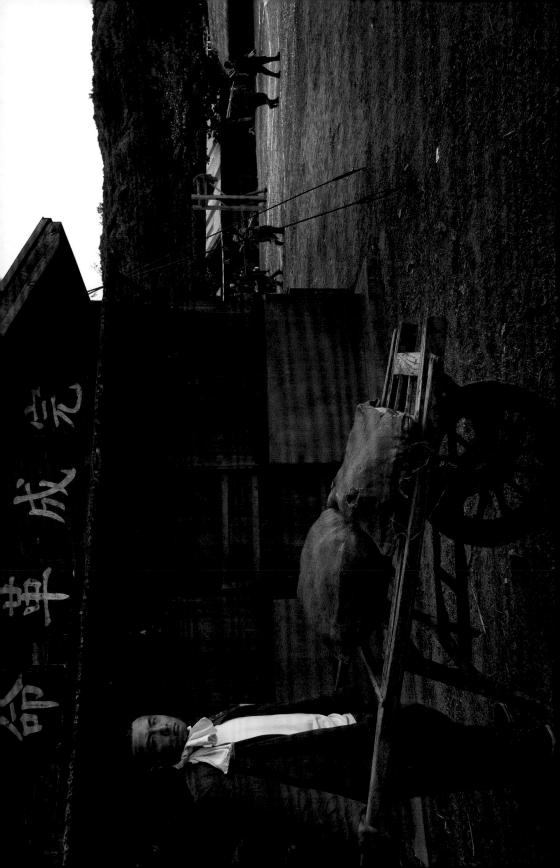

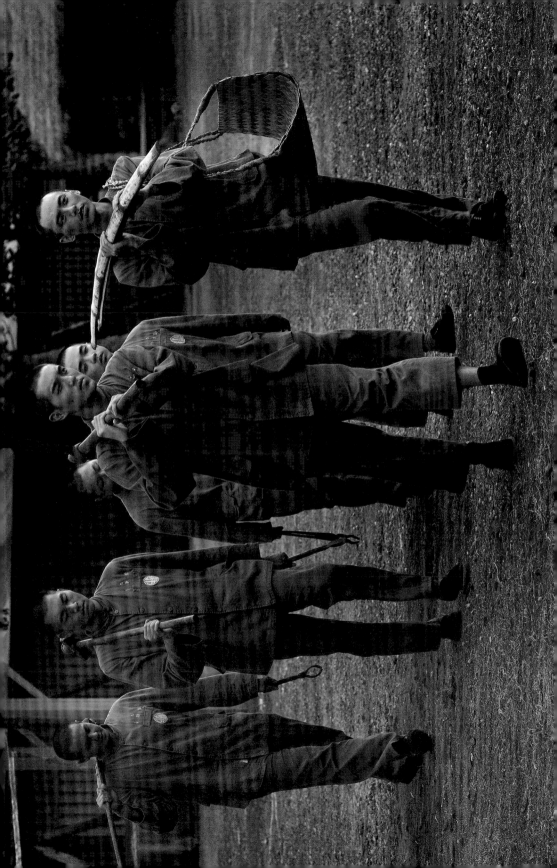

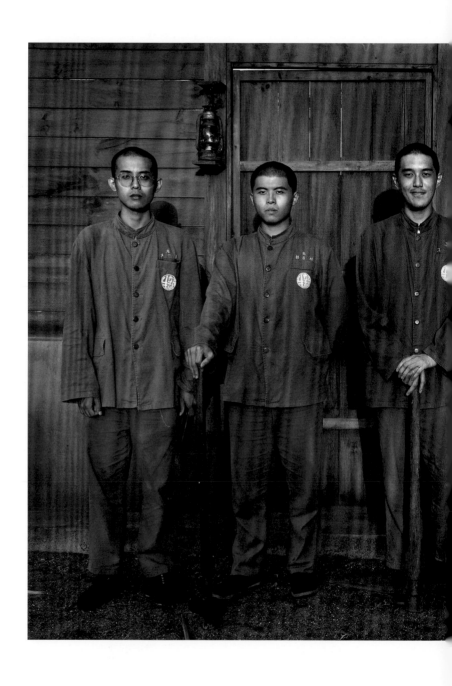

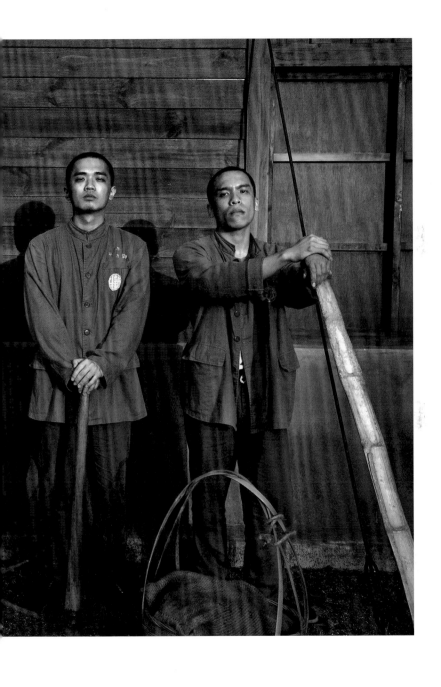

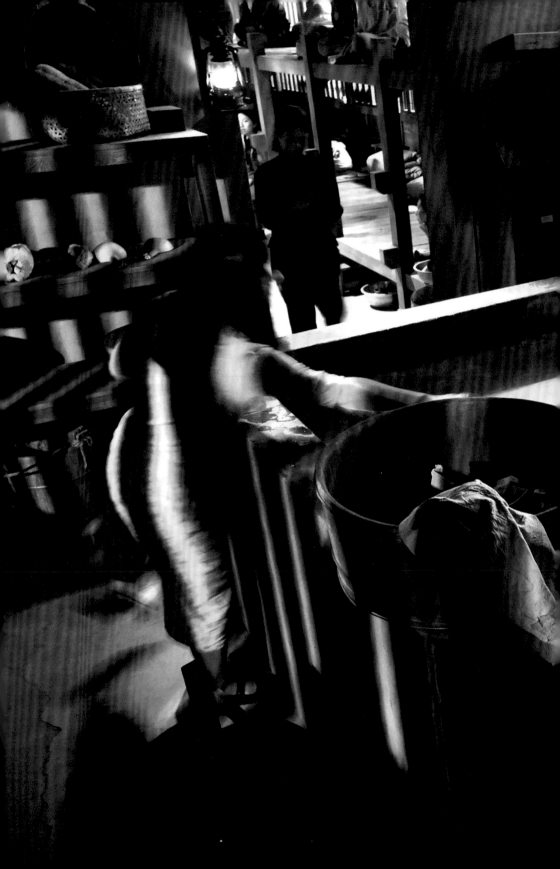

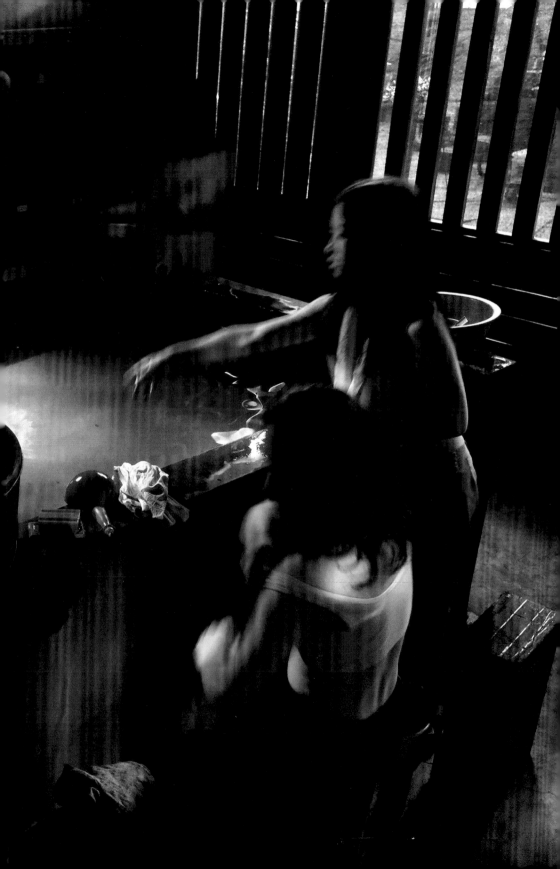

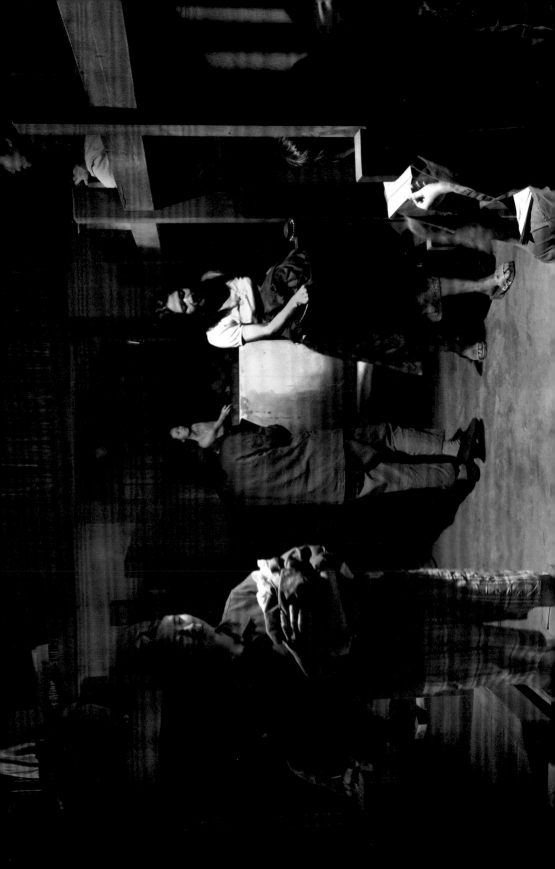

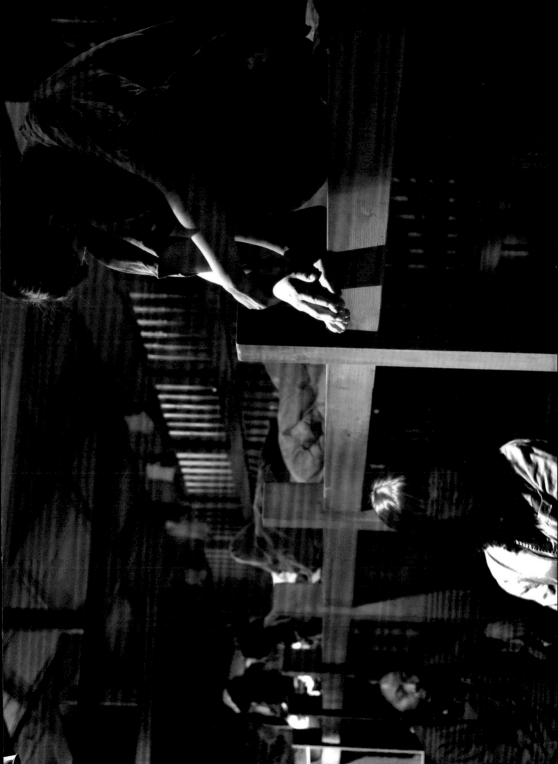

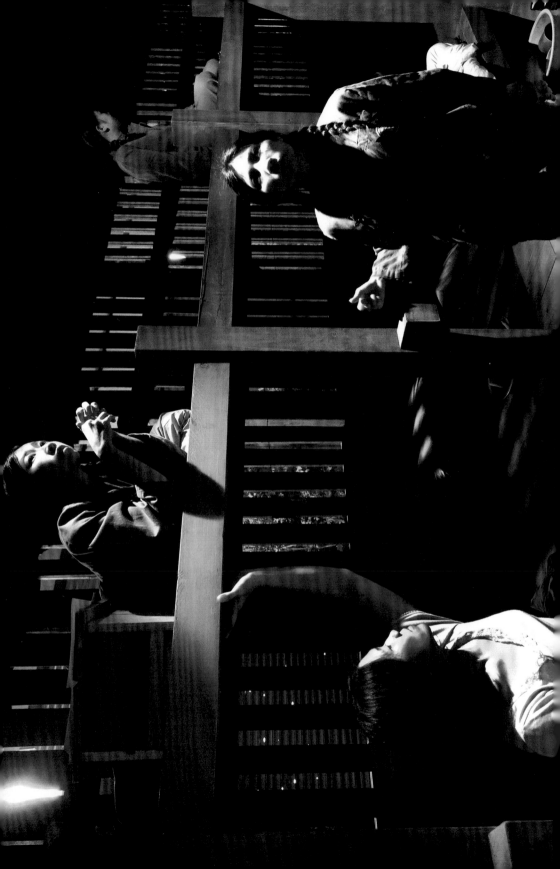

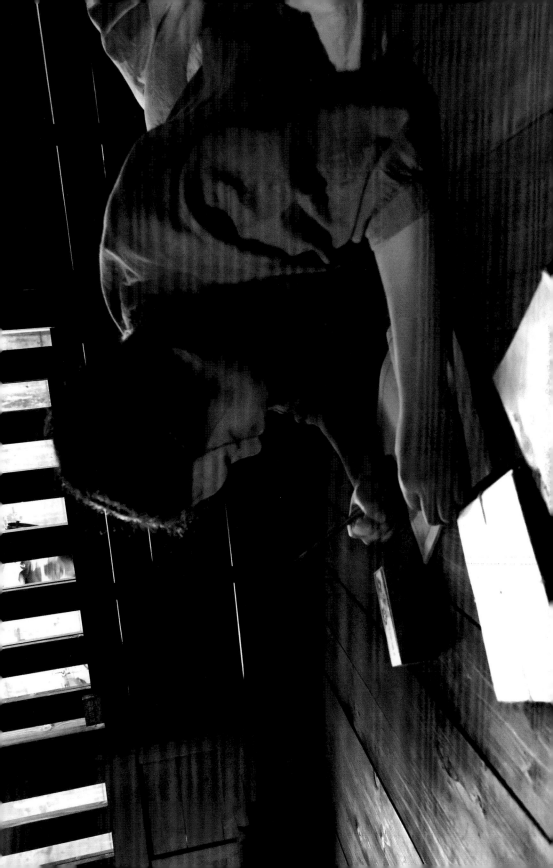

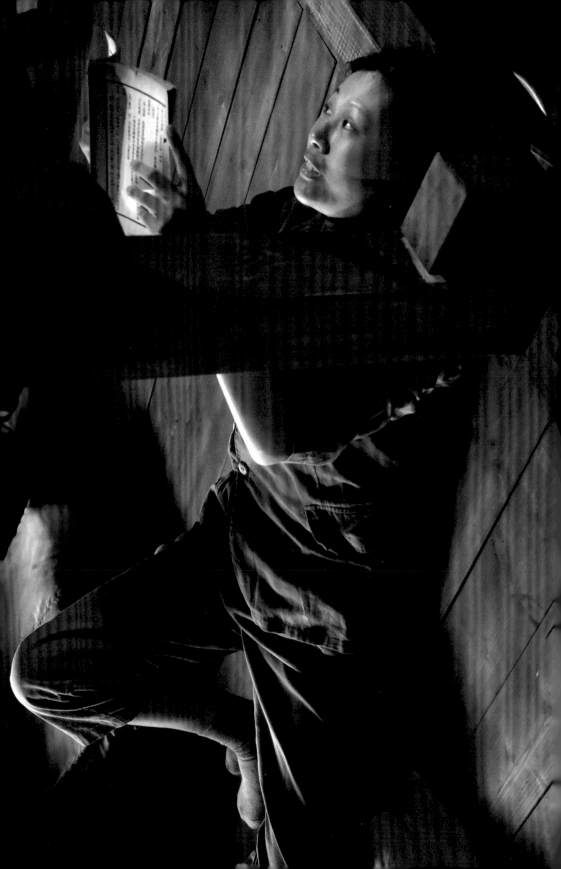

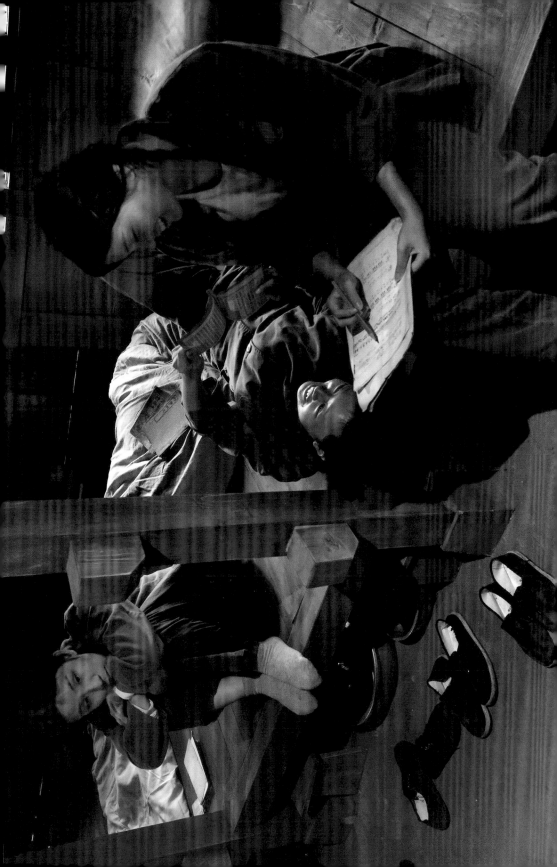

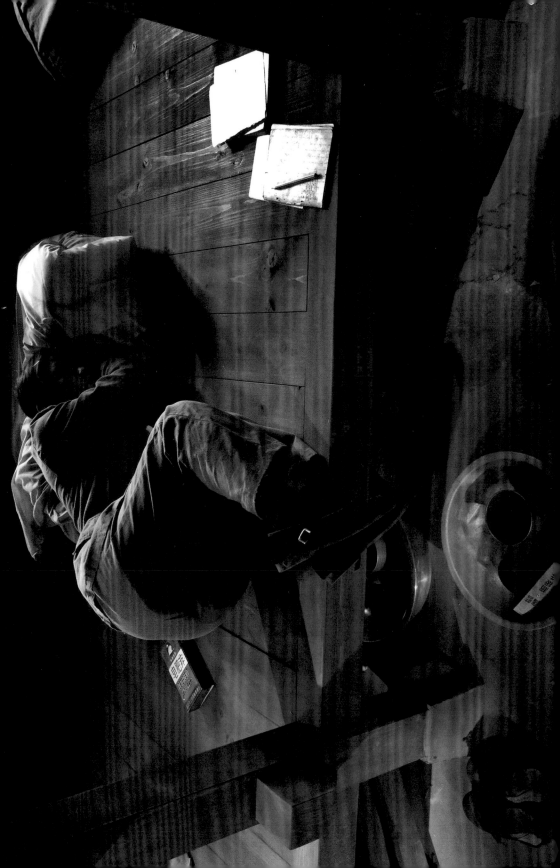

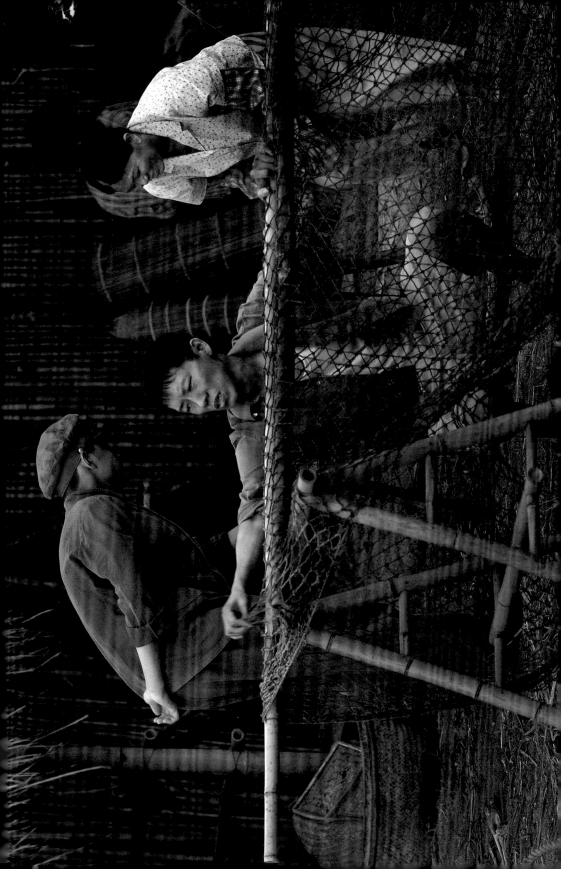

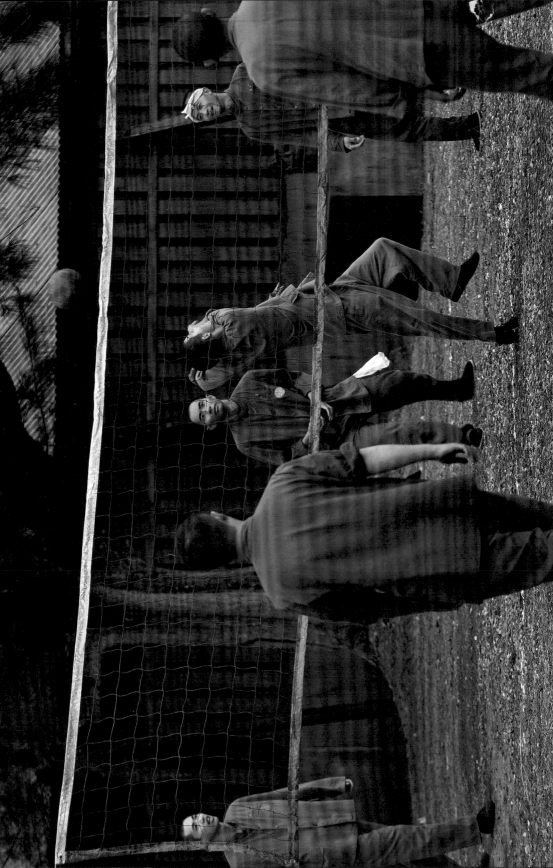

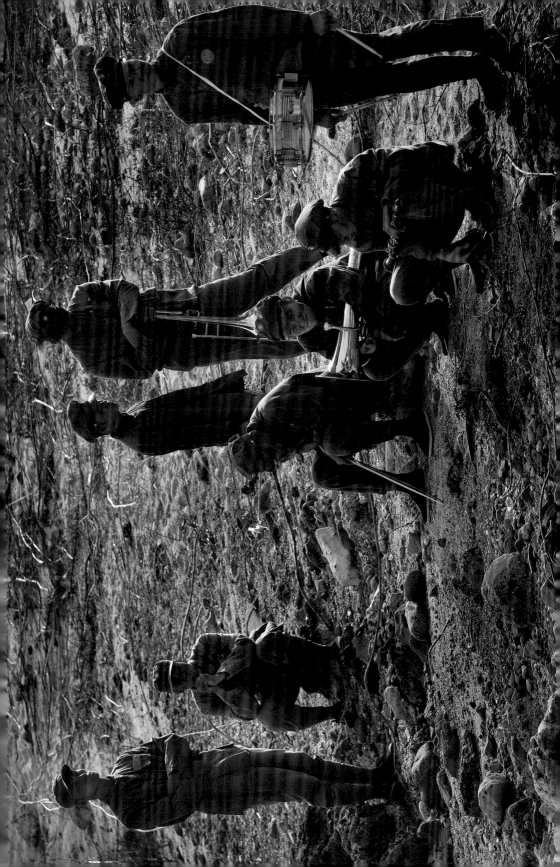

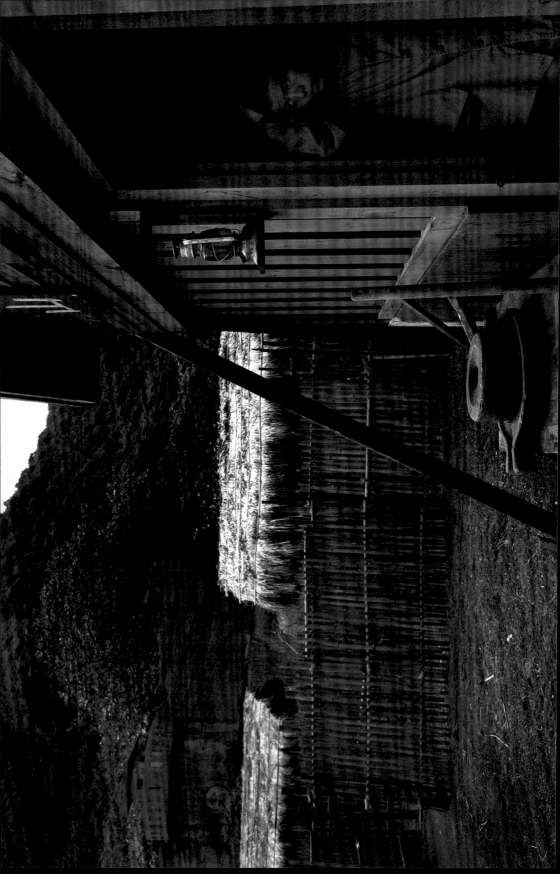

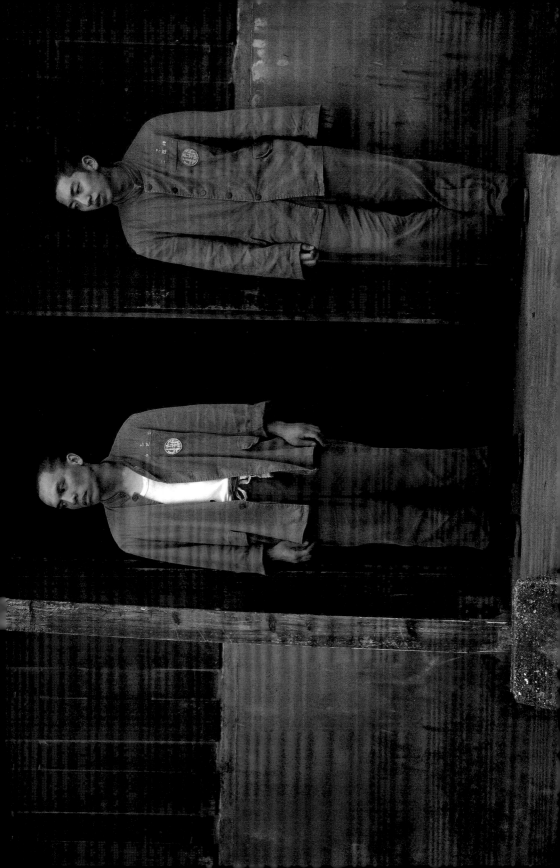

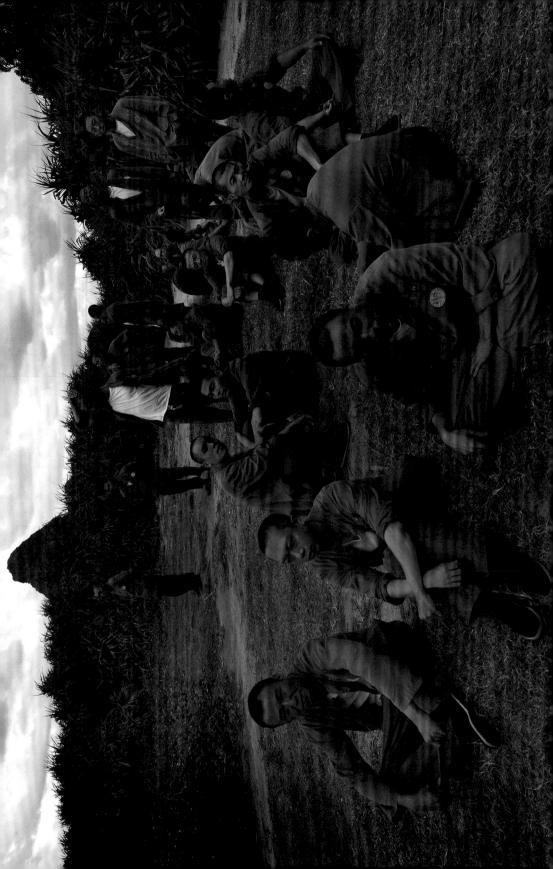

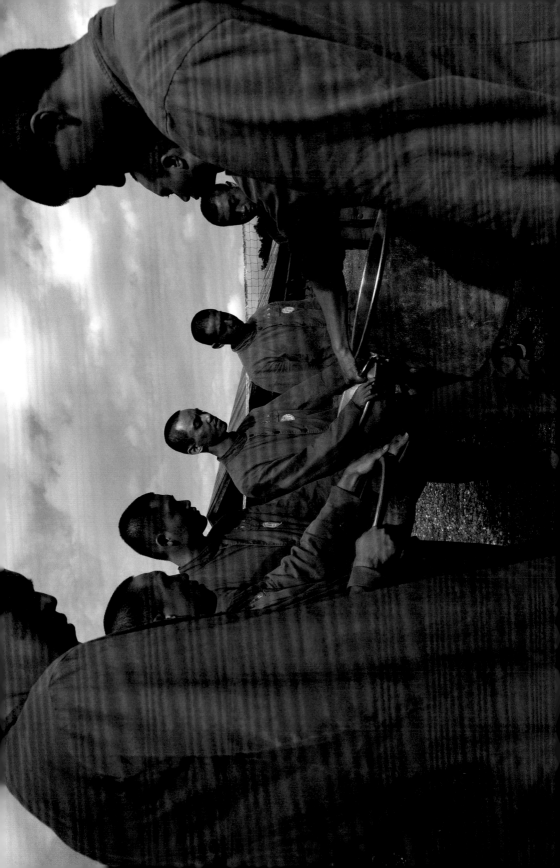

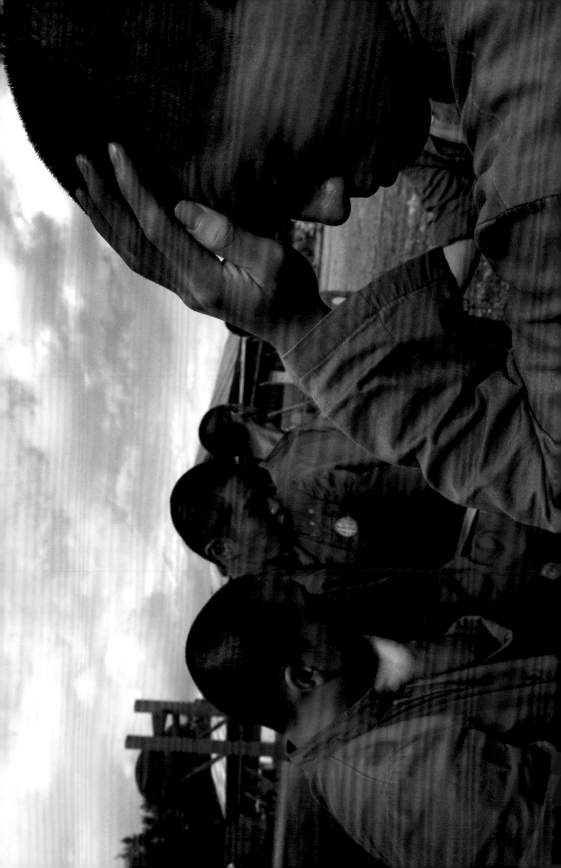

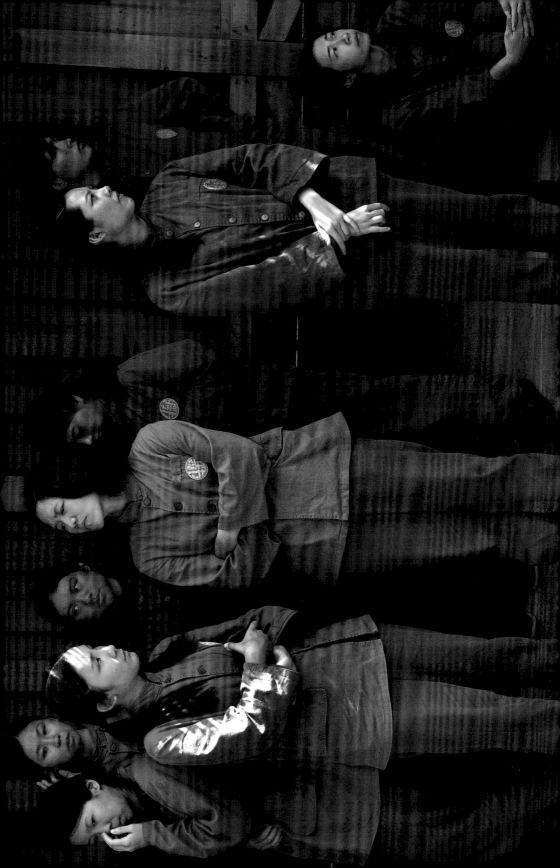

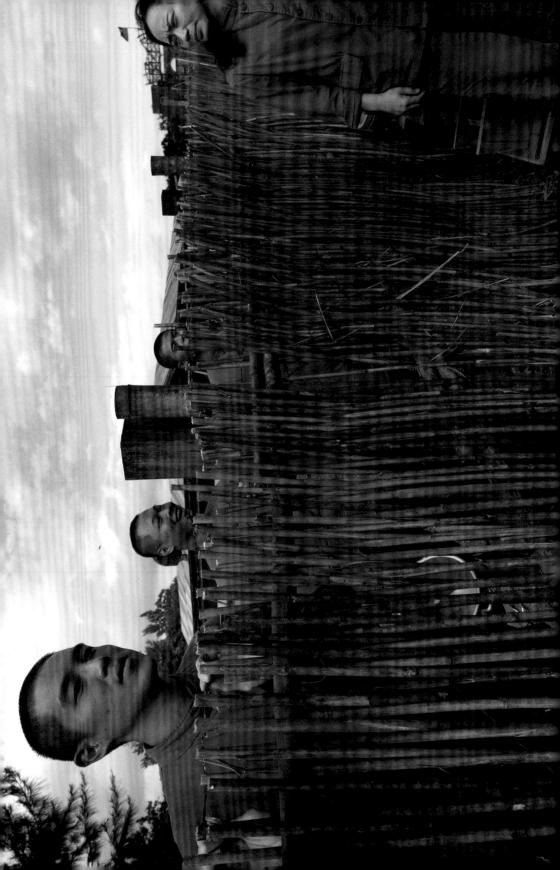

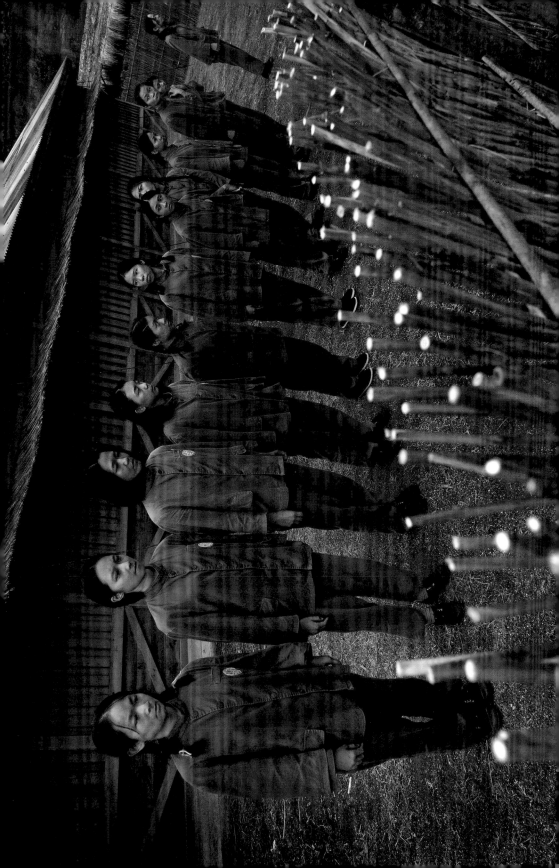

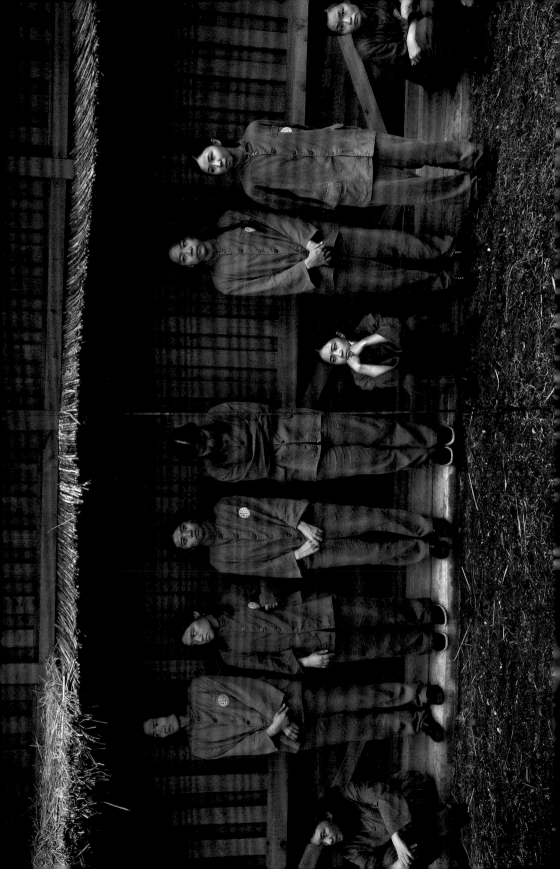

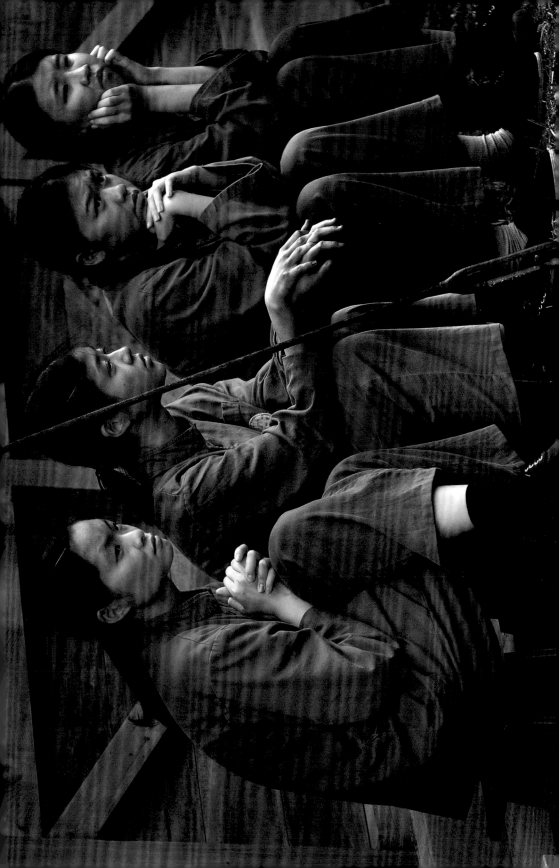

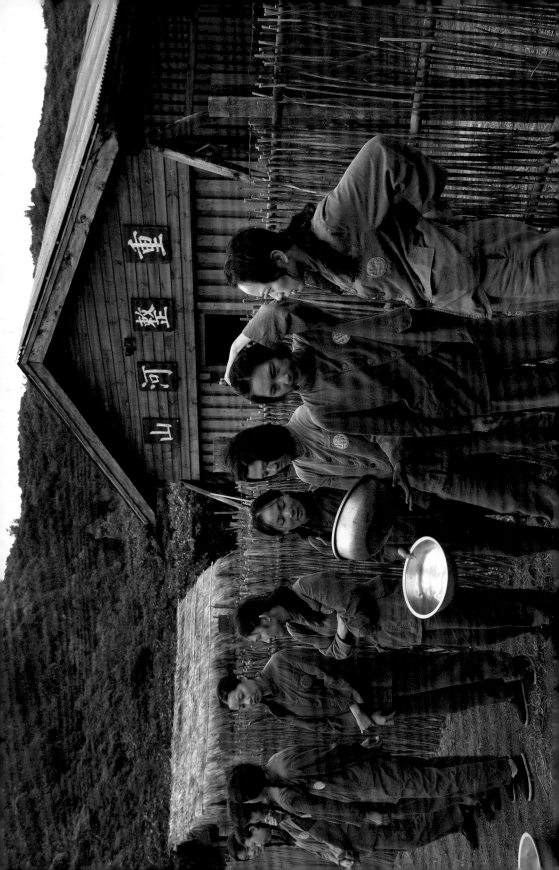

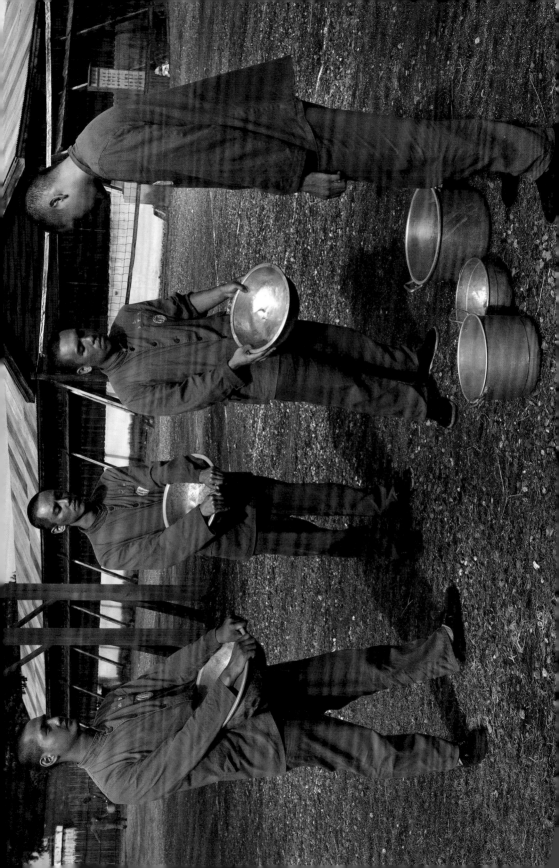

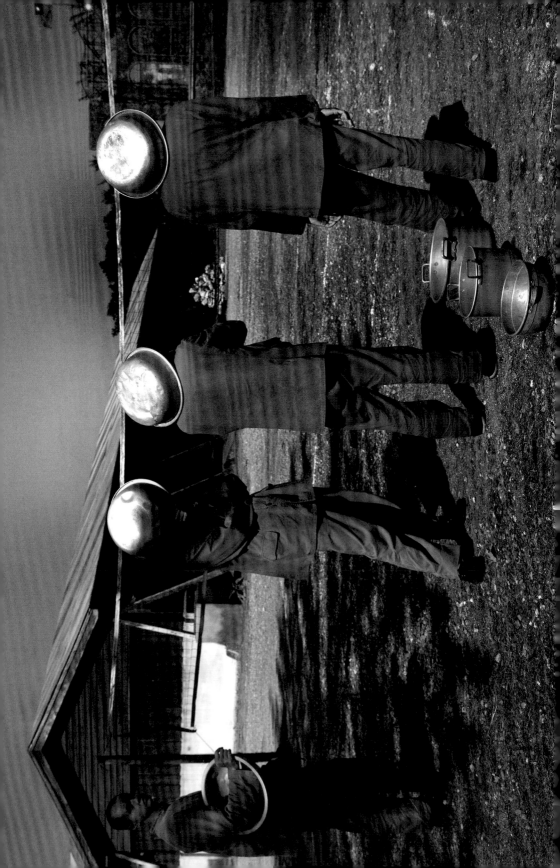

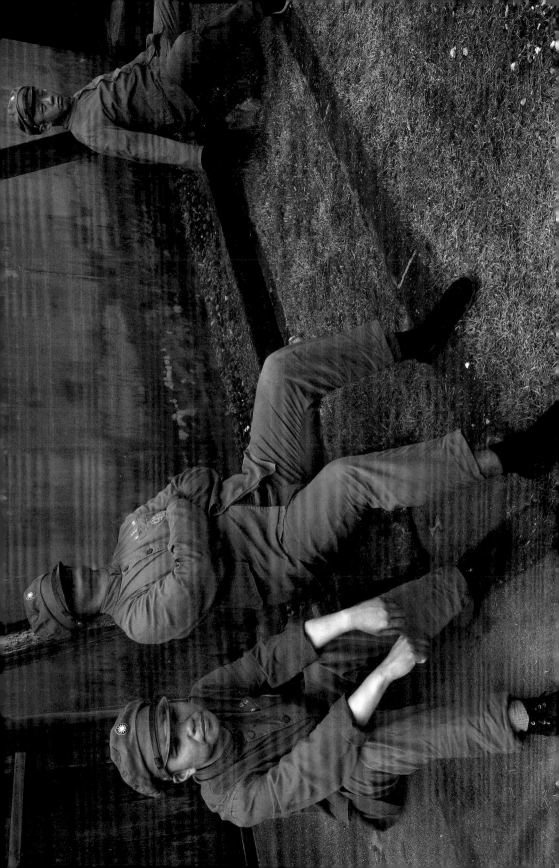

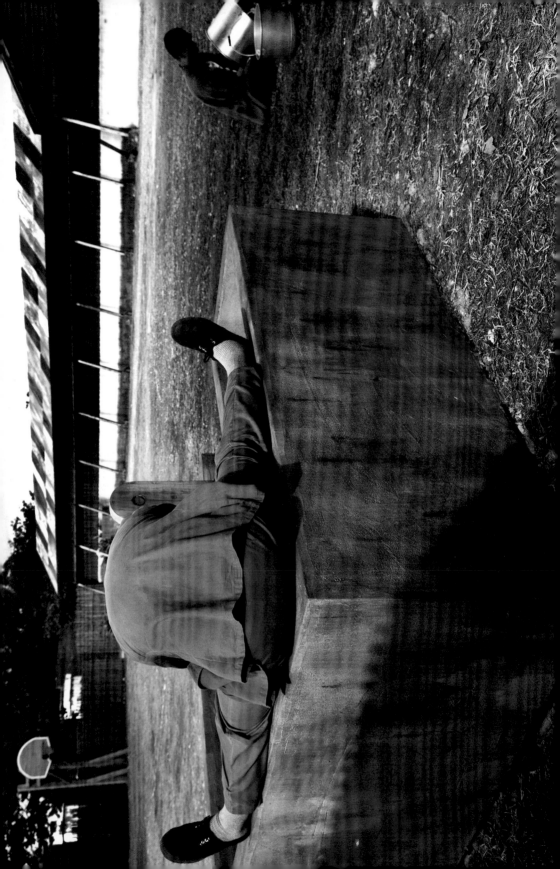

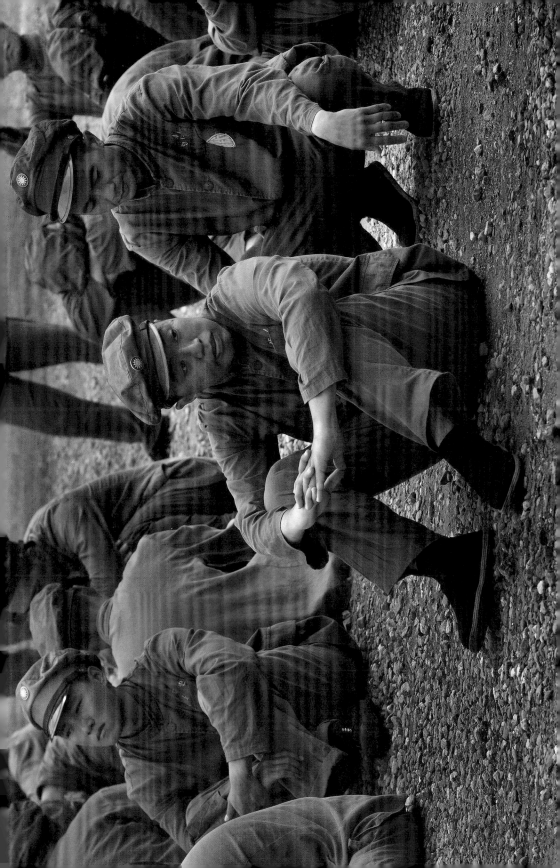

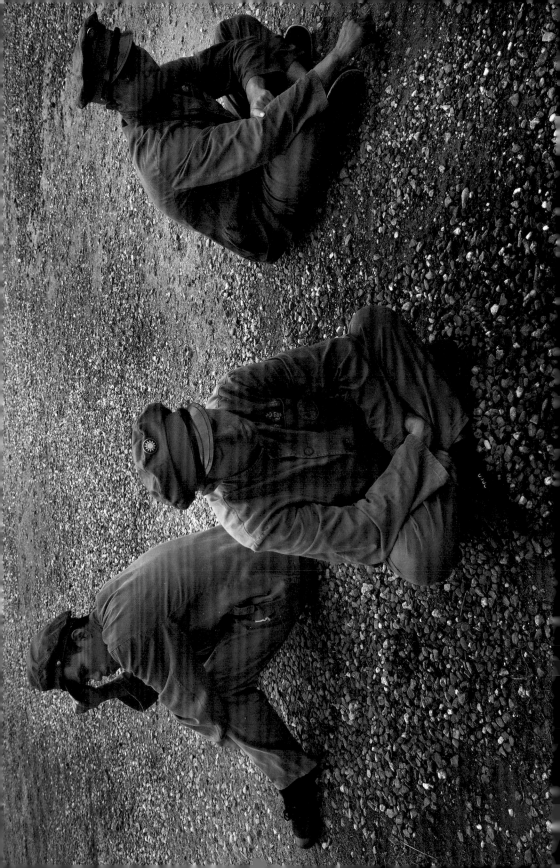

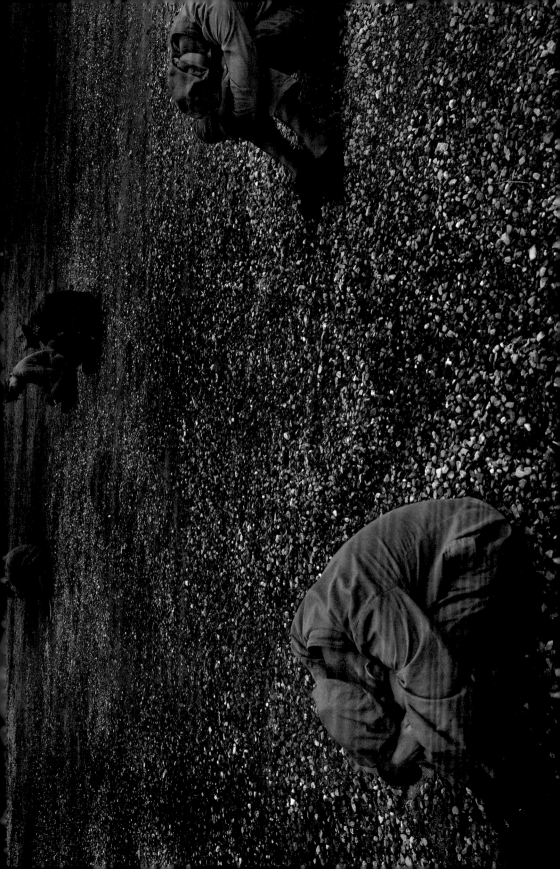

1991年初登火燒島

那一年，動員戡亂時期終止，警備總部綠島指揮部解散，綠島也開放了觀光。

行政院新聞局組團邀請記者登島參訪，雖然官方招待必然是經過修飾美化的行程，然而有機會一探仍然鮮少對外開放的綠島監獄，還是催促著我成行，並在短短的幾個小時內，留下了那些島上威權遺緒的氣息。

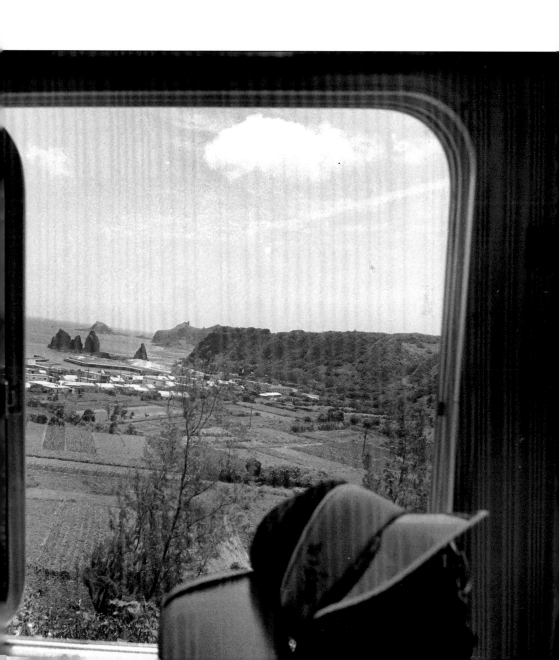

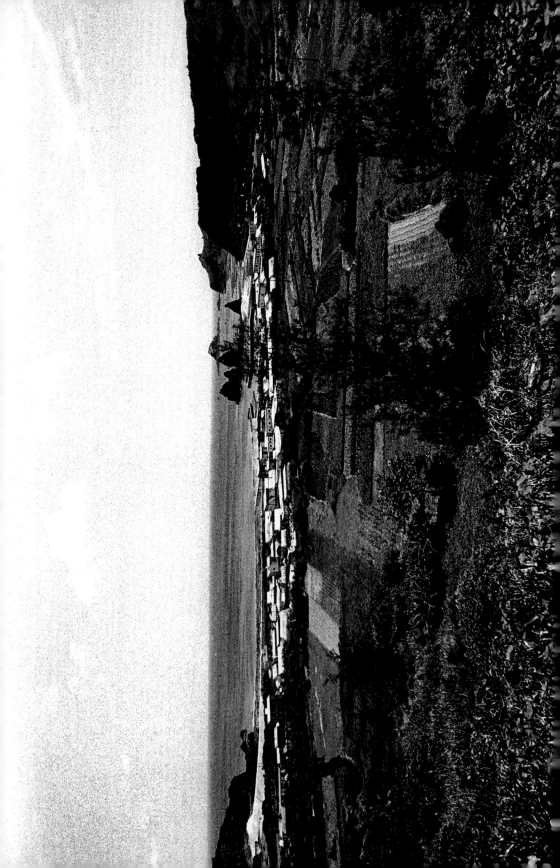

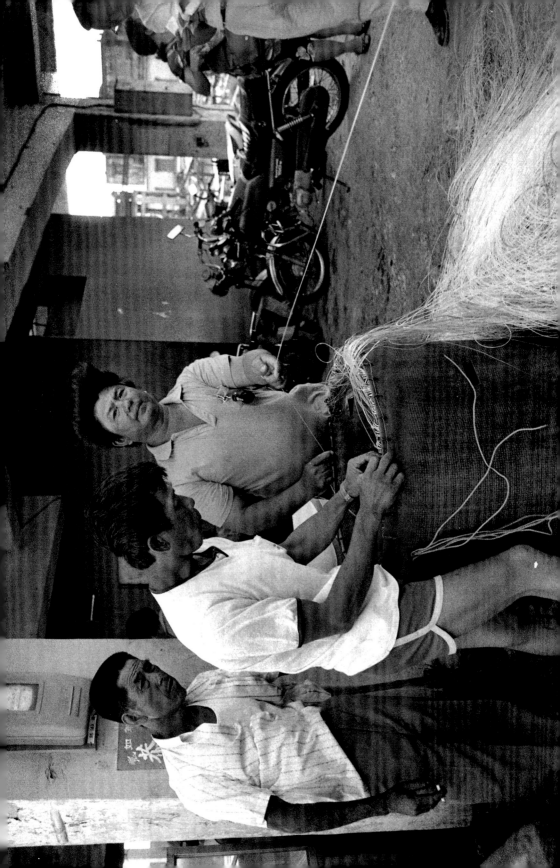

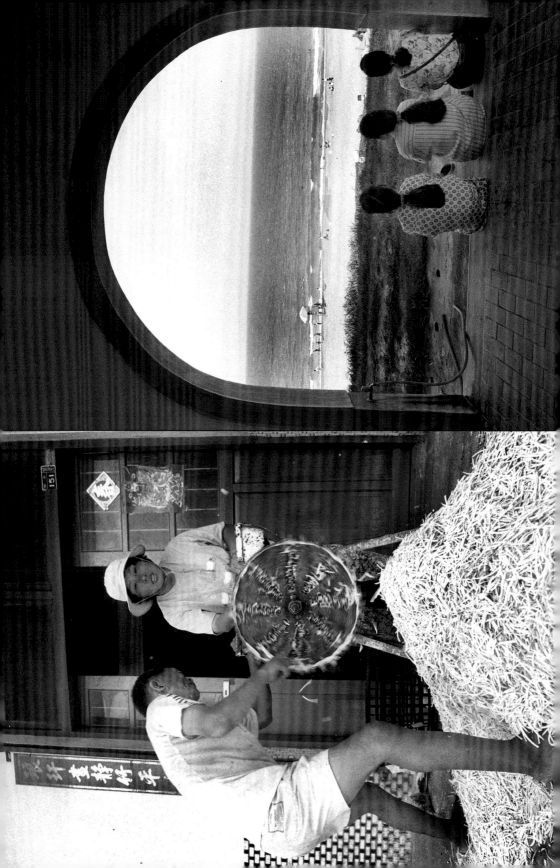

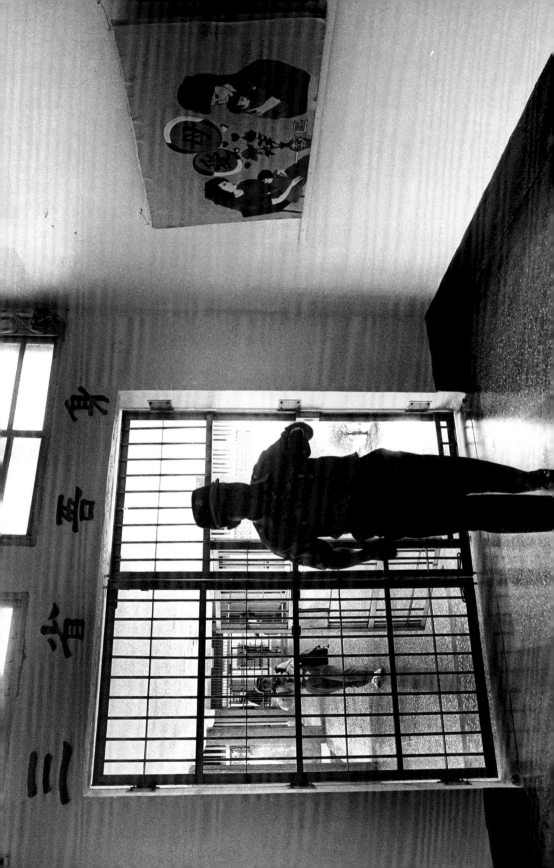

女思想犯與政治犯

一九五〇年代初，綠島新生訓導處曾關押一批女思想犯，被稱為「綠島女生分隊」。

這五名年輕女性白白失去了青春、自由，甚至生命。

她們原本是充滿希望的優秀中學生、單純的主婦、有錢人家的小姐，某一天，突然被收押禁見，輾轉牢獄，甚至遠送綠島，人生就此變了調。無法想像的監獄生活，思念、茫然……種種一切，衝擊著她們失去自由的心靈。

彼時，是個有著「思想犯」的年代，在女思想犯外，更關押了不計其數的前輩政治犯。

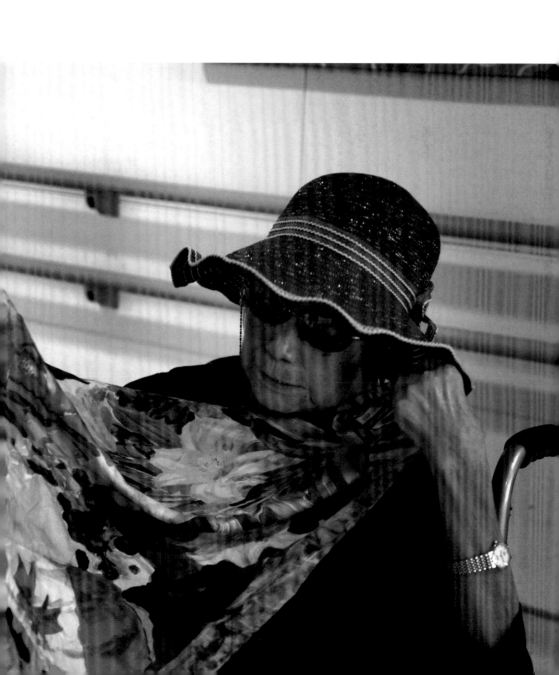

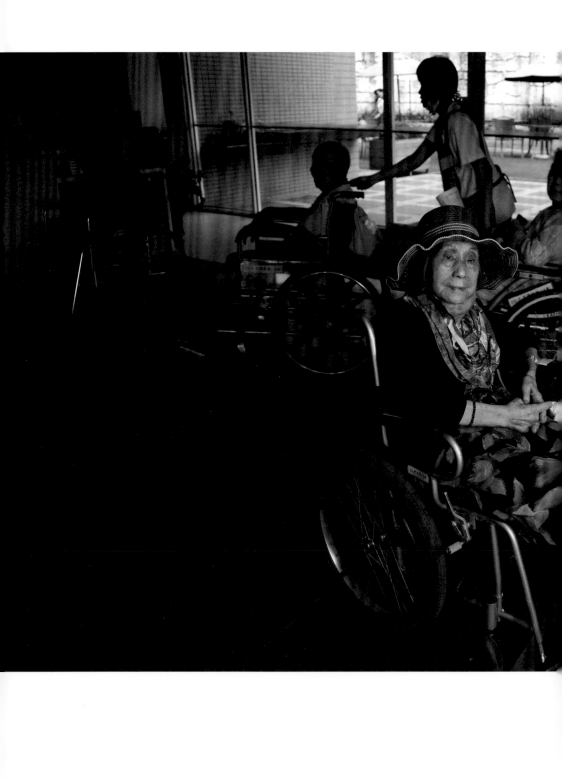

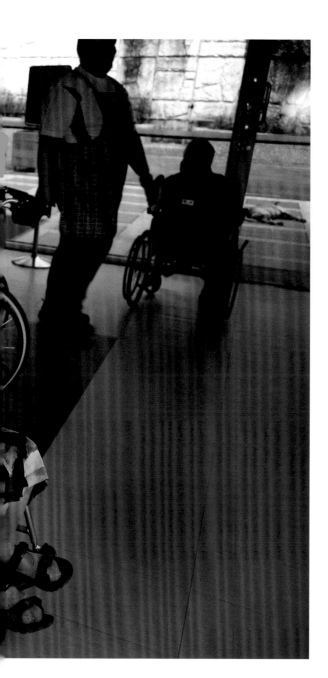

陳勤

「天空在屋頂的那一端」

原本期待燦爛歲月的未來，不料婚後不久即遭無妄之災，身繫囹圄五年六個月又十六天。

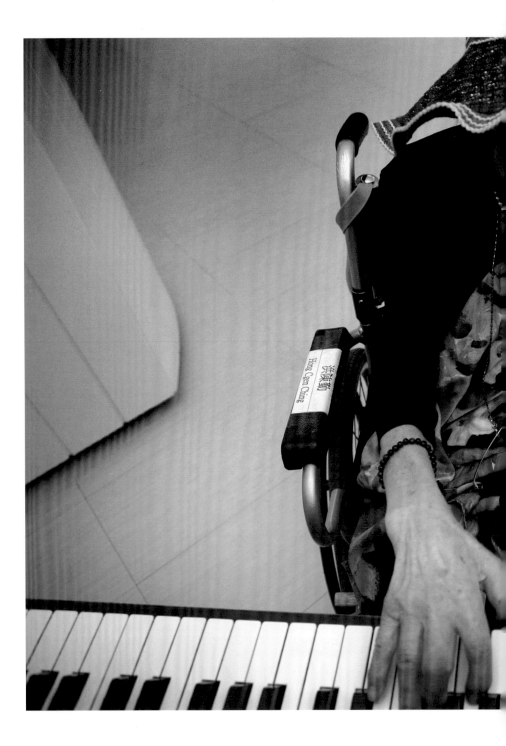

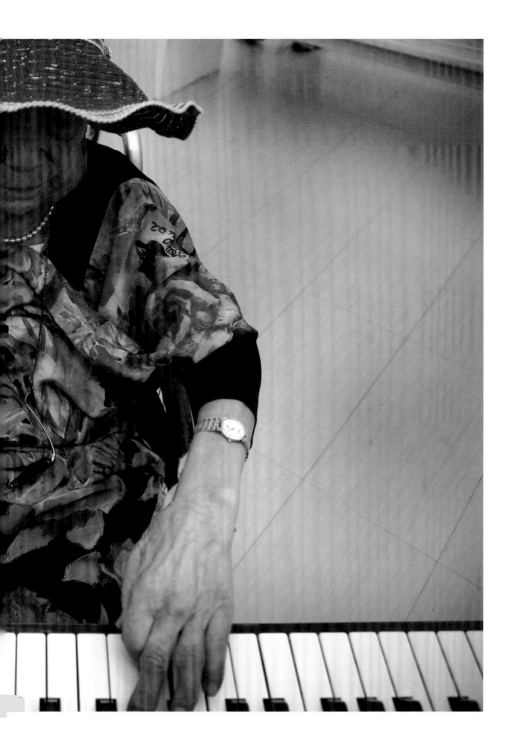

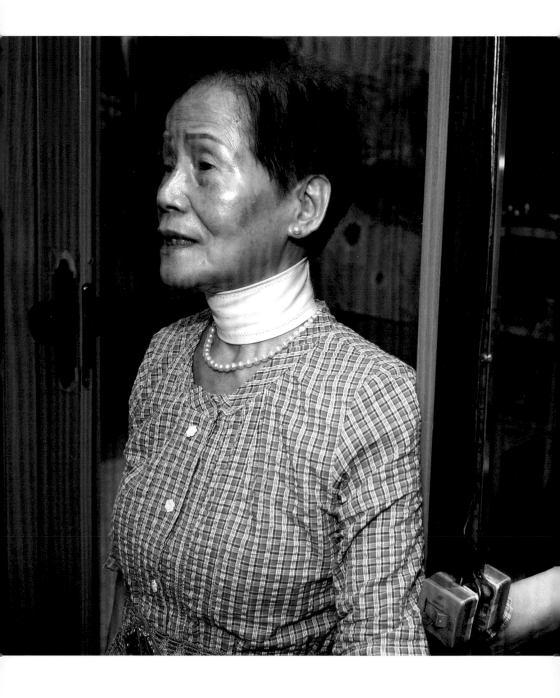

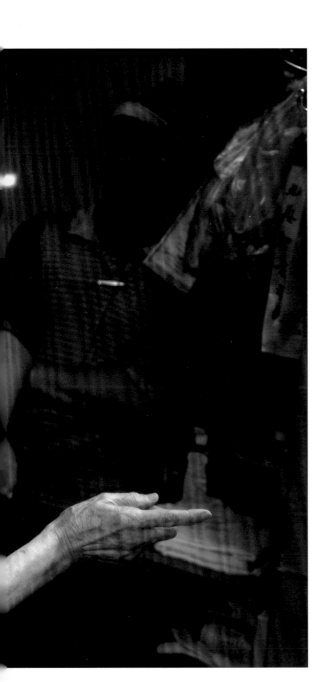

黃秋爽

「我家七人被抓」

我被判刑時，沒有拿到判決書，我爸爸也沒有判決書，因為家沒了，沒地址可以寄。

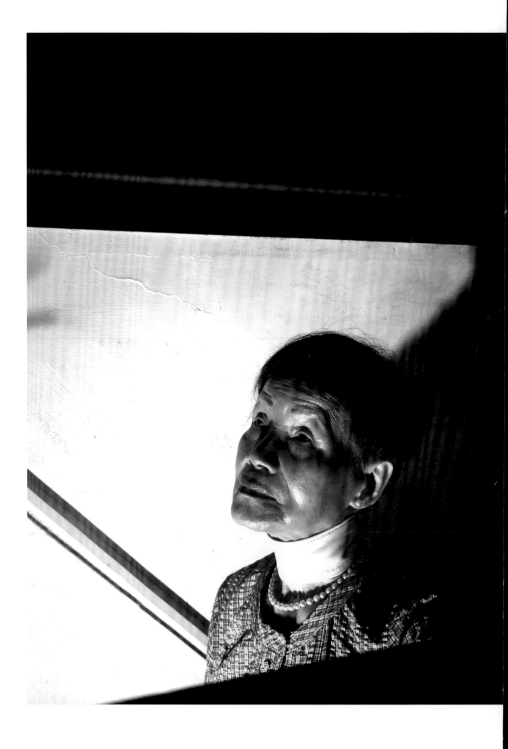

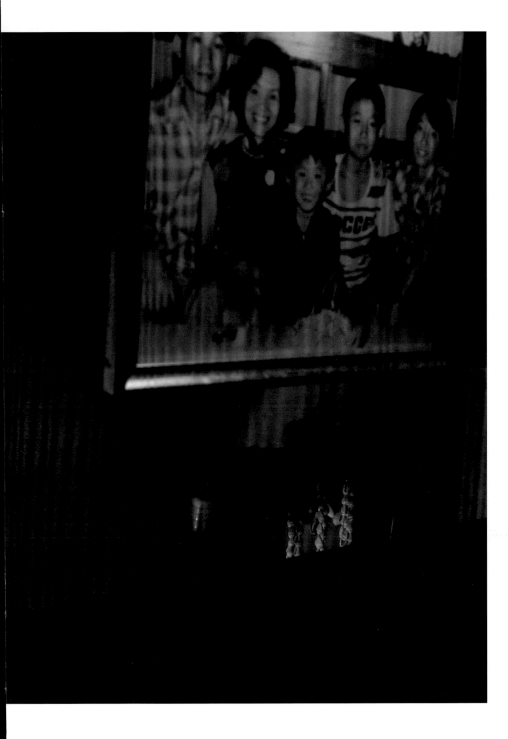

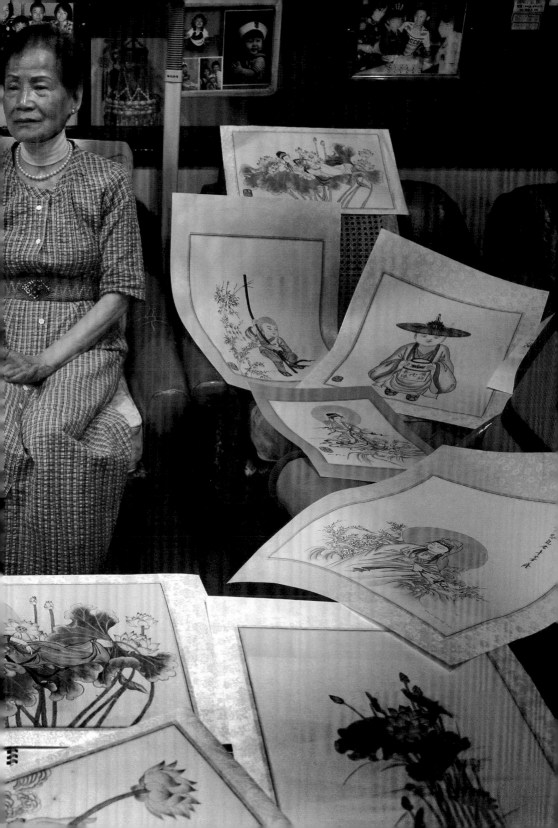

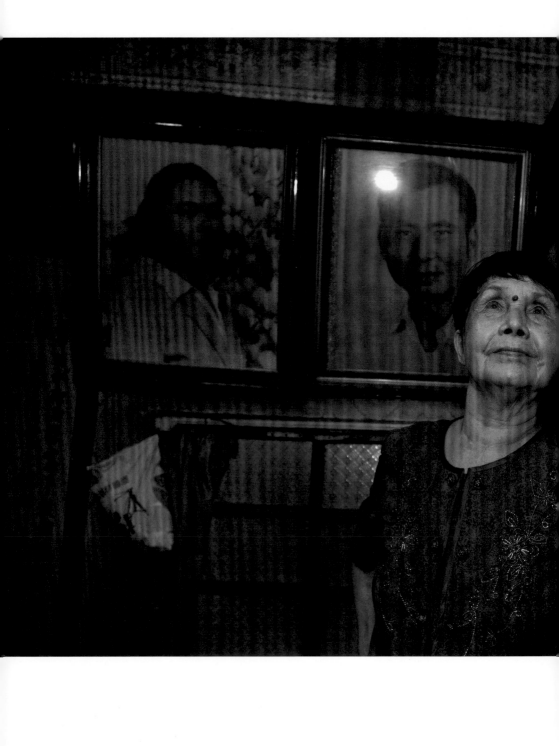

張常美

「無辜的九十九人」

老蔣說：「寧可錯殺一百個，也不要放掉一個」，

我就是其中的九十九個。

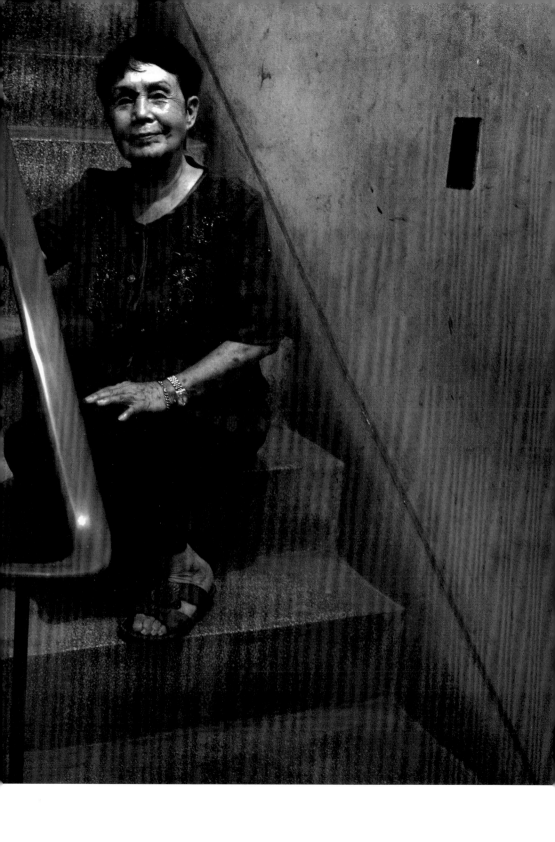

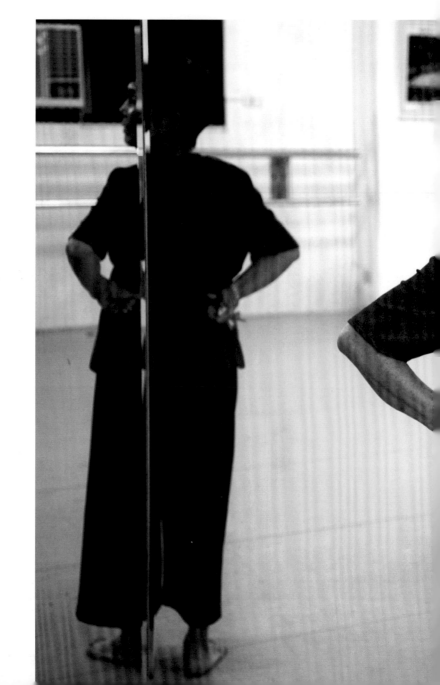

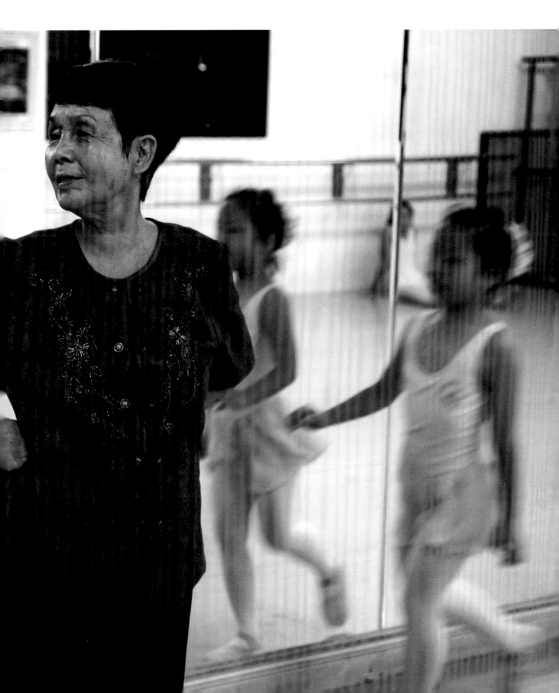

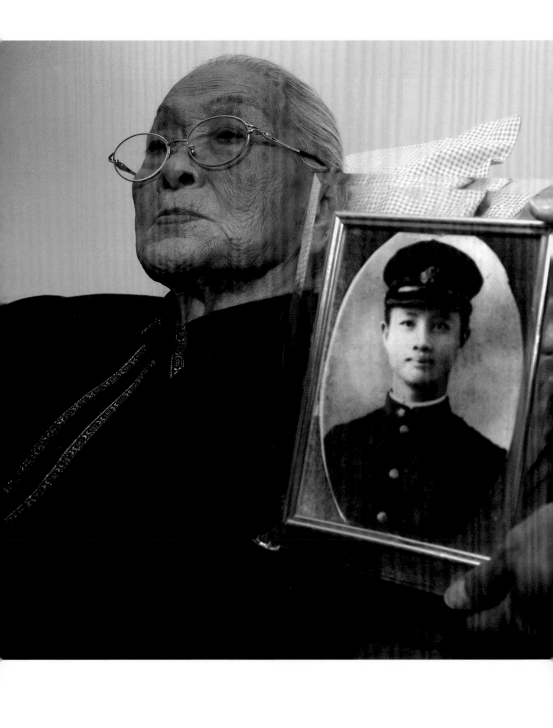

藍張阿冬

「帶著一歲女兒藍芸若入獄」

他們來抓時，女兒才一歲多，我正抱著她餵奶，看他們一堆人進來，我的腳就軟了，手還抱著女兒吃奶。

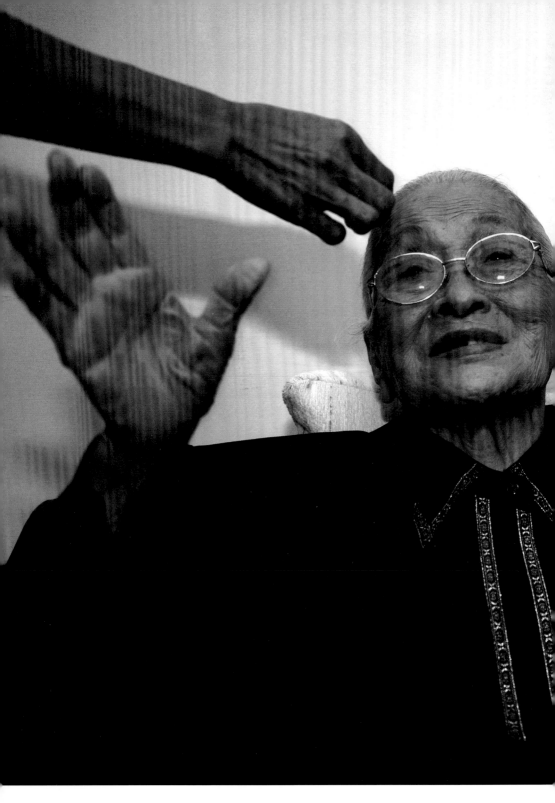

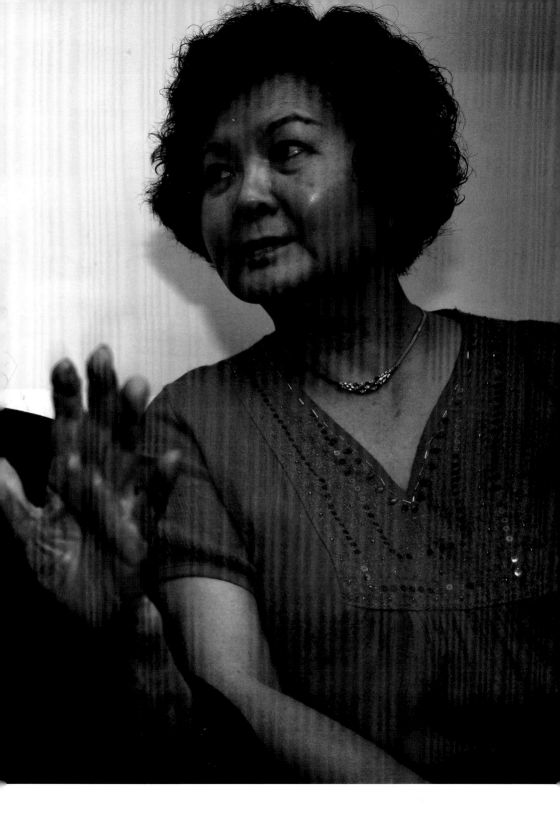

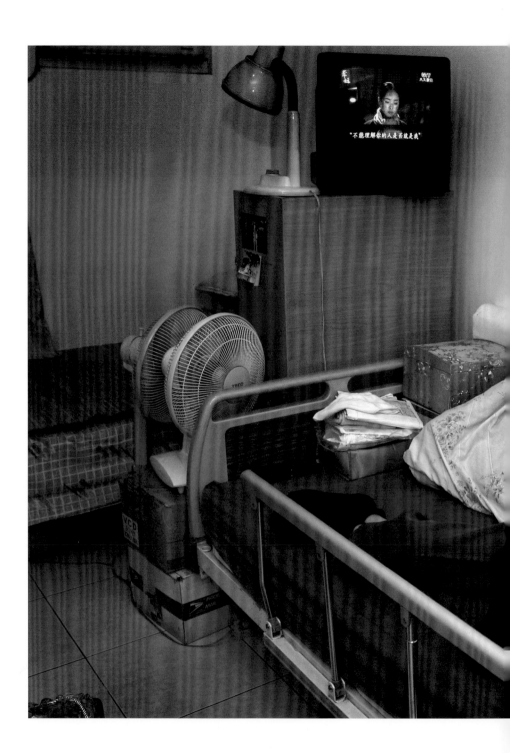

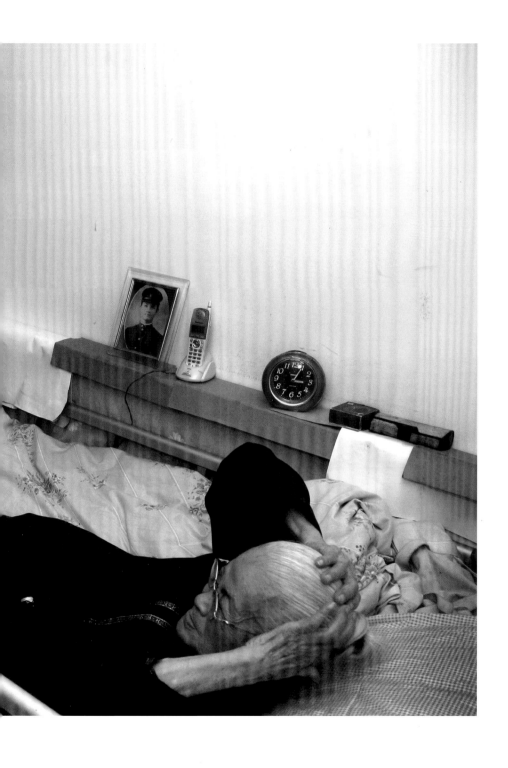

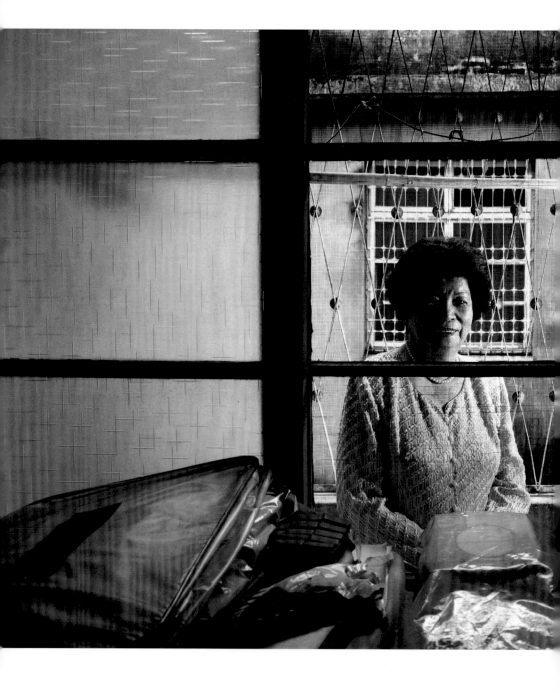

張金杏

岩石縫長出的小草

「我這個政治犯絕對要做給你看，我絕對要比那些沒有被關的人更屬害、做得更好，就是要走出來給你看。」

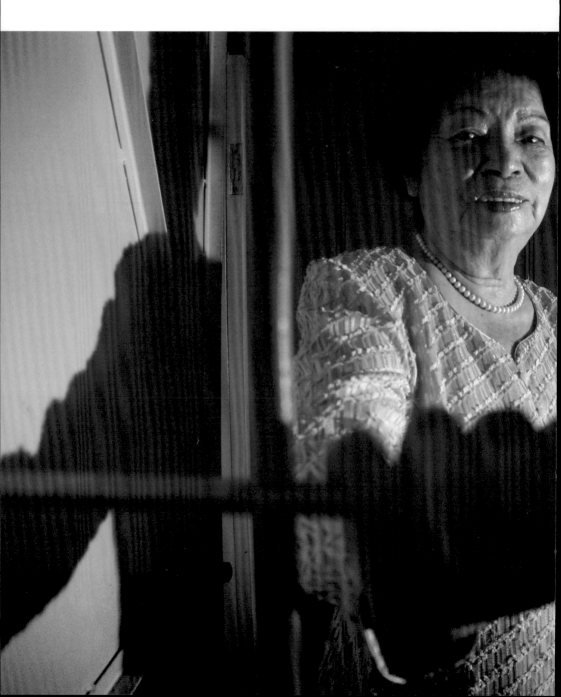

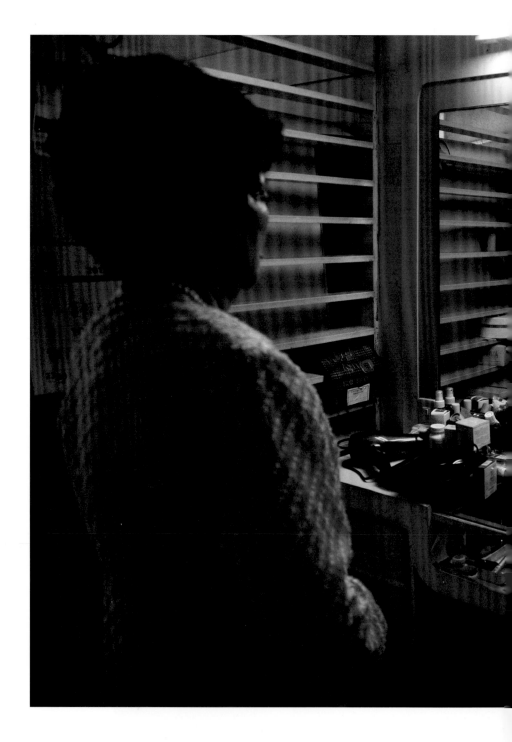

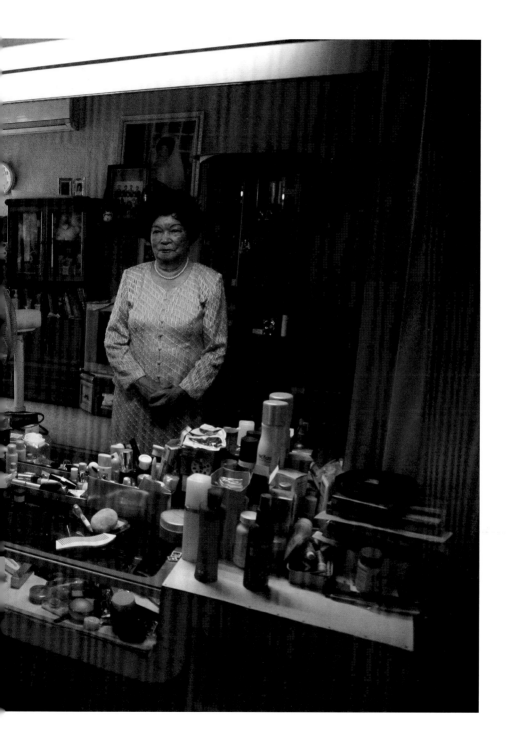

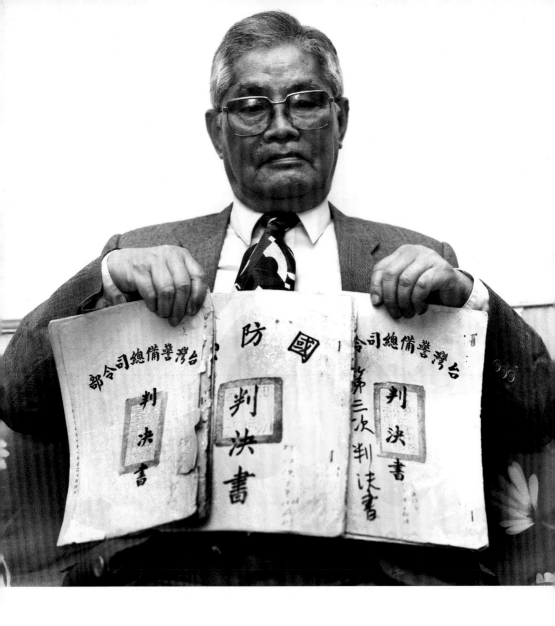

黃紀男・1992.05.10

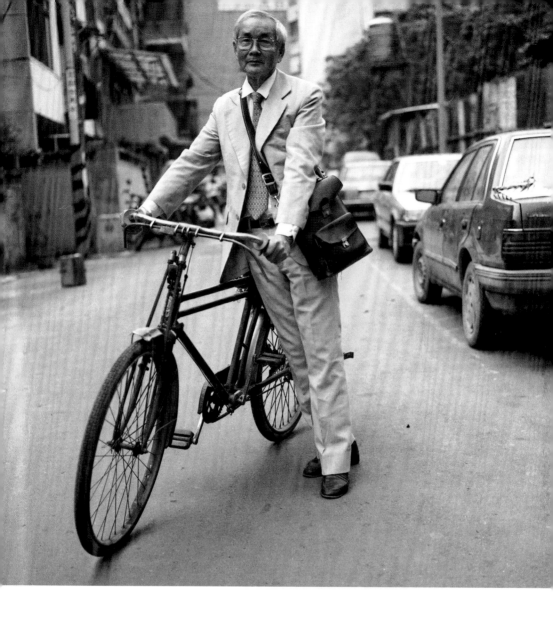

洪文慶・1992.05.06

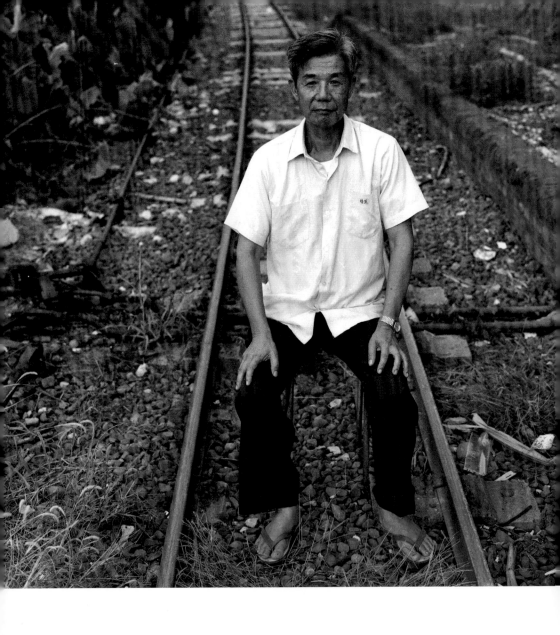

溫連章・1992.08.26

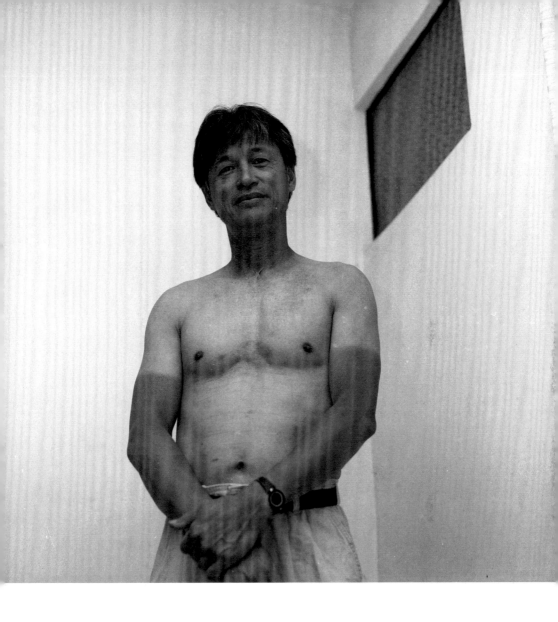

王幸男・1992.05.10

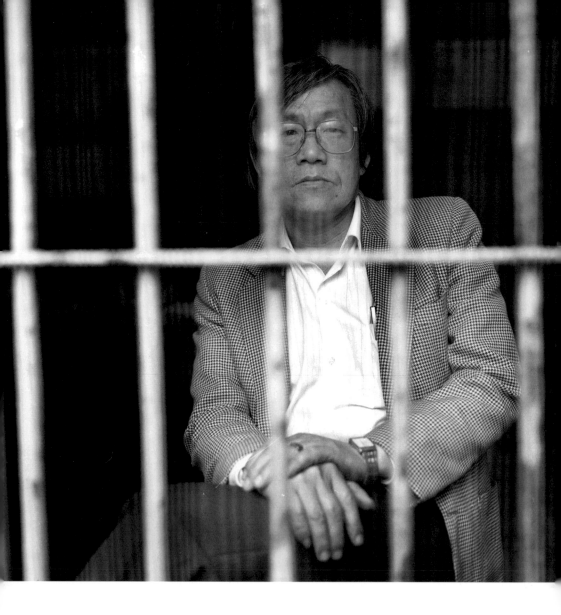

林樹枝・1992.03.26

柯旗化・1992.04.29

蔡寬裕・1992.05.12

川流翰史壯節

碧蘊青山涵岳

楊碧川・1992.03.28

尊嚴名灣人

郭清淵．1992.04.30

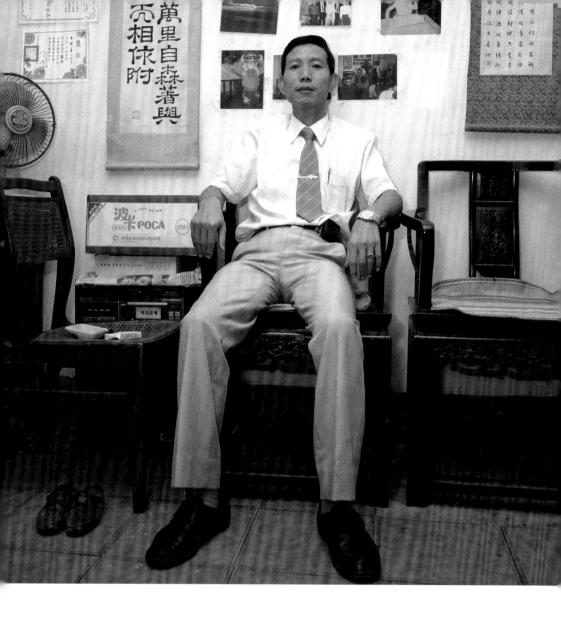

周順吉・1992.07.20

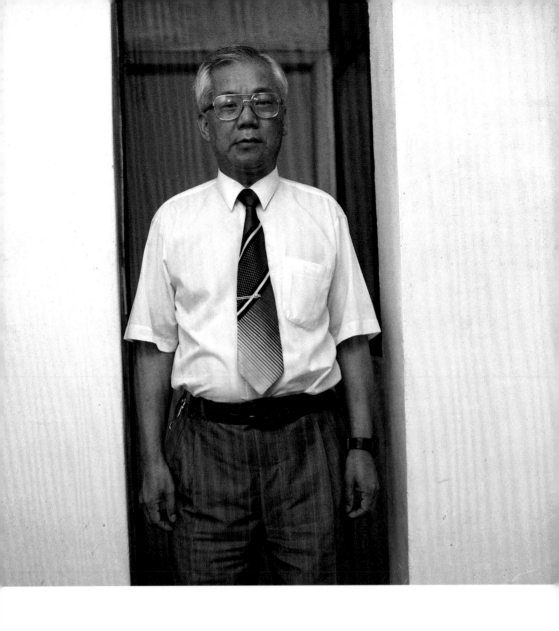

林水泉・1992.05.06

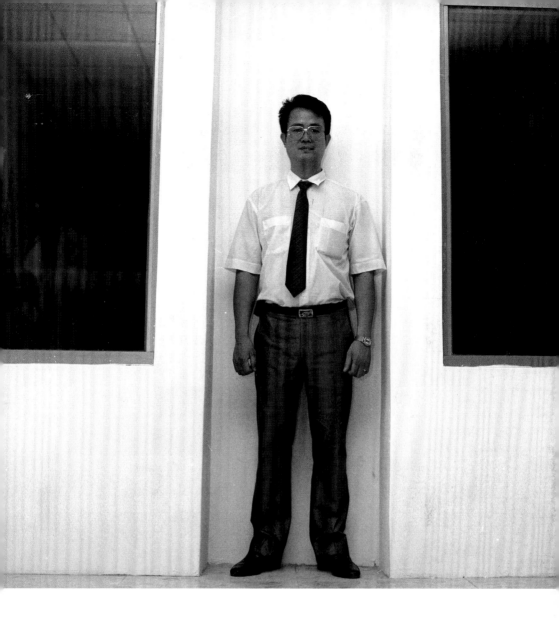

黃坤能・1992.09.01

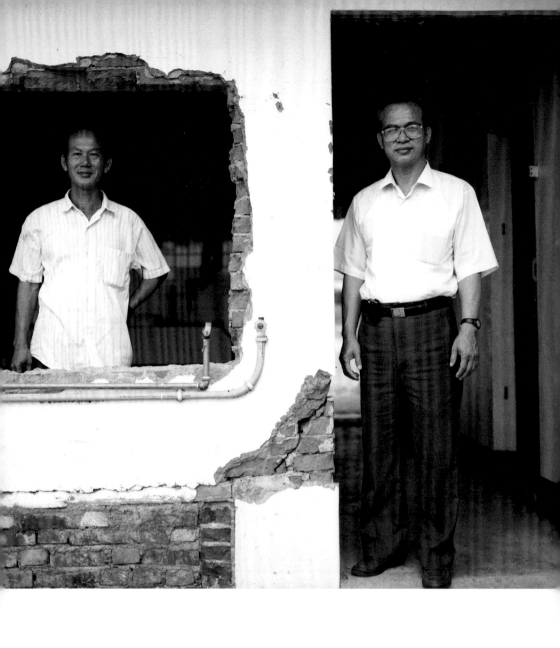

陳三興、陳三旺・1992.04.30

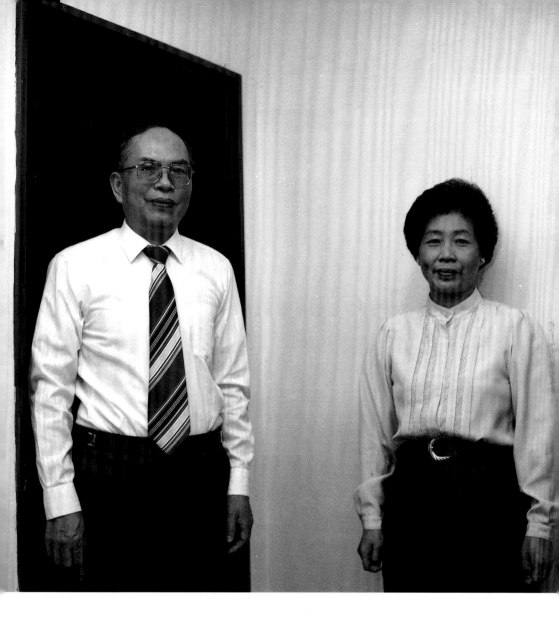

劉炳煌、謝秀美・1992.04.15

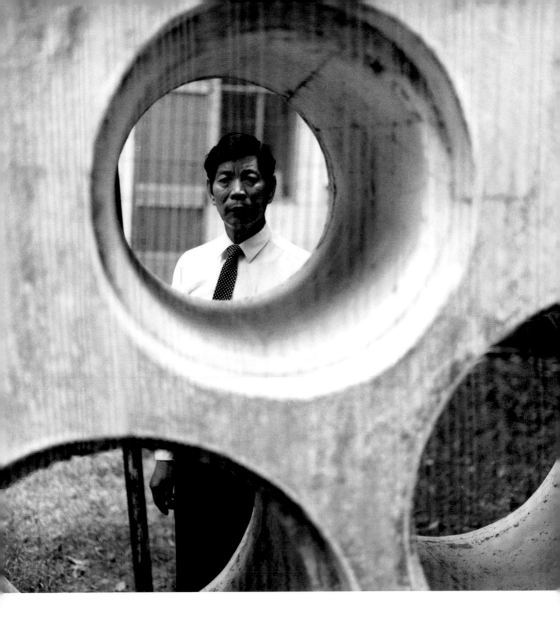

楊金海・1992.08.25

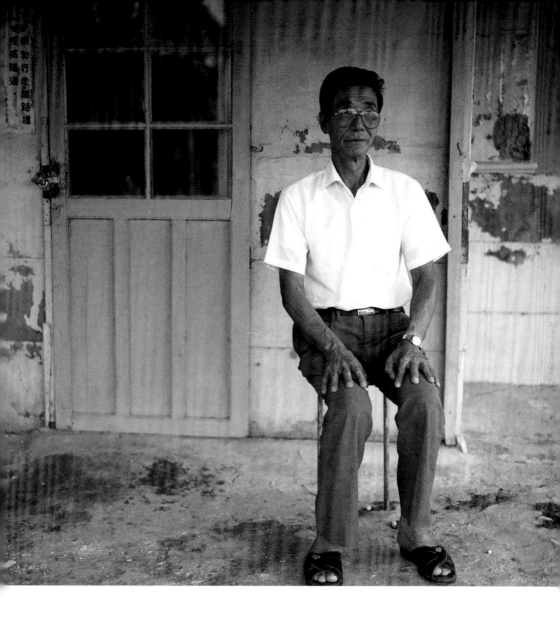

姜啟我・1992.08.26

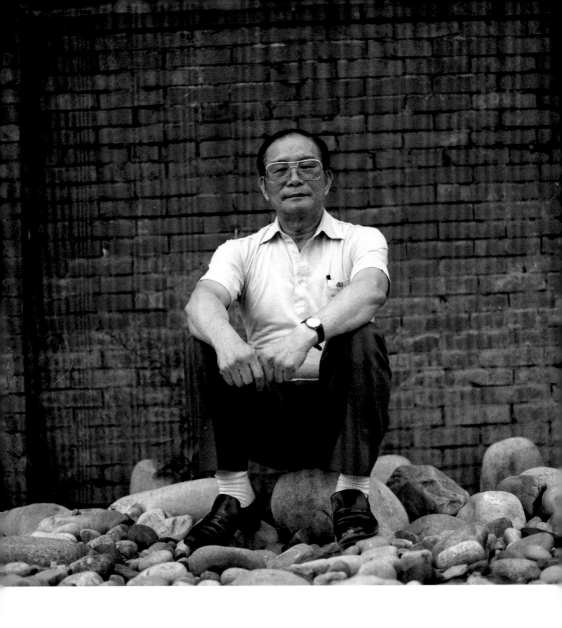

黃金島・1992.09.01

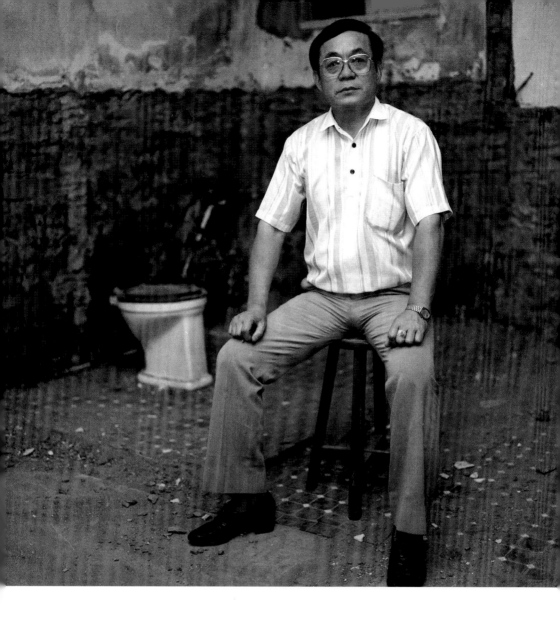

鄭清田・1992.05.07

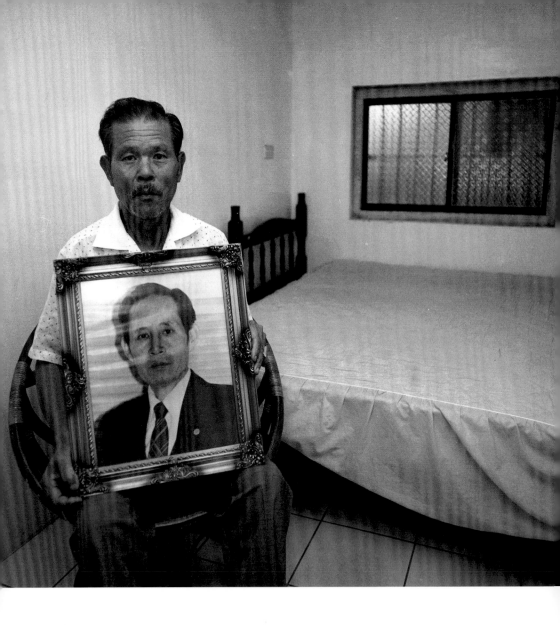

張世欽．1992.09.01

黃華・1990.07.15

序

我很晚才真正踏上綠島，還沒到綠島前，聽聞許多老政治犯提過他們在島上發生的種種。白色恐怖時代，因政治思想不容於執政當局，他（她）們被遣送至這邊陲離島，遠離自己的家人、美好的生活，從社會菁英成了監獄囚犯，雖然面對廣闊的海與天，卻無路可去、也無路可退。

還是記者時，因採訪接觸到了曾被關在「火燒島」的前輩，聽他們提及當年在島上的遭遇，總覺除了口述歷史，我們無從得知當年是如何付出沉重代價的，如果有人忠實記錄下就好了，沒有任何貼近事實的影像留下，只有官方樣板的宣傳，那些血淋淋的史實會不會就此被遺忘？我心裡這麼想著。

1990年因為新聞工作接觸了很多昔日的政治犯，對於台灣過去的白色恐怖、政治黑牢產生好奇，促使我著手拍攝老政治犯，這個計畫以被關了十年以上黑牢的民主前輩為拍攝對象，前後大約執行了一年多，拍了七、八十人，最後卻忍痛放棄整個計畫。因為在拍攝過程中，我看見了被扭曲後的人性，讓我無法再繼續。

當時聽到許多民主前輩談及他們被拷打、逼供的審訊過程，但最讓我震驚的不是這些，而是他們本是感情甚篤的同窗，因為同個案子入獄後，在審訊過

程中被分化，造成昔日的革命同志互相猜忌，懷疑自己被出賣？即使已時隔數十年，早已遠離了黑牢，但心中仍難掩憤恨，採訪過程中屢屢聽聞批鬥昔日同志，讓我非常痛心、按不下快門，索性放棄了拍攝計畫。

1991年，當時的行政院新聞局組團帶記者到綠島參觀，我知道這是「官方」安排的行程，一定處處都是美化後的不真實場景，但那時綠島監獄鮮少對外開放，不願錯過難得的機會便欣然接受官方的招待，首度踏上綠島，「入監」一探究竟。

那時的綠島沒什麼觀光客，一切還很純樸，單純的漁村人情跟我的故鄉澎湖很類似，難以想見這裡曾經有過三個拘押思想犯與一清專案的監獄。我們在安排下被帶進了「崇德新村」參觀，整排牢房已被整理得乾乾淨淨，完全看不出昔日眾多人犯、思想犯被拘禁於此的痕跡。

綠島為什麼會被當成羈押重刑犯的好地方，因它四面環海，而且都是礁石地形，還有山作為屏障，想跑也跑不了。當年的政治犯不乏醫生、教師、建築師、工程師等社會菁英，他們被關在綠島時，偶也貢獻一己之力，當島上缺乏醫生，他們就幫人看病；老師不夠，他們就重操舊業；當沒人知道工程該如何做，他們就恢復自己建築師的本業，只是蓋的是囚禁自己的監獄。

印象最深的是所方介紹了「放封」的地方，天氣好時能清楚看見本島，當年這些老前輩隔海望著台灣，心裡的絕望與無奈恐怕不是我們所能想像。

除了未完成的老政治犯肖像計畫，2012年接受《流麻溝十五號》口述歷史一書作者曹欽榮的邀請，拍攝了1950年代的台灣女政治犯，該書其中一位女政治犯施水環小姐已於1956年遭槍決，所以我只拍了其中倖免的五位。拍攝過程中聽聞許多她們在綠島黑牢的過程，但過去來不及參與，也不可能參與，只能記錄下離開綠島多年後，她們當下生活的樣貌。

2021年底，前立委姚文智轉入電影圈，籌資拍攝以《流麻溝十五號》口述歷史為背景的電影，他與該書原著作者曹欽榮問我有沒有意願到綠島看看拍片現場，同時拍攝一些照片。出發前我數度猶豫，甚至想要作罷，因為拍美美的劇照並非我的強項，但我心中仍然想去看看現場，看劇中的場景是不是如

當年老政治犯跟我說過的一樣，最後我只帶了三套衣服就前往綠島，告訴自己如果拍不到畫面就回來，最後就靠著這三套衣服在綠島撐了半個月。

我在綠島時努力拍攝著不是「劇照」的劇照，試圖重塑五〇年代老政治犯所說的牢獄模樣，以無聲的照片記錄電影情節。這些照片不是為了電影而拍，而是希望藉由這部電影的拍攝，能重塑當年火燒島上的情景，我想像自己就站在白色恐怖時代的綠島，企圖拍下那些當年不被看見的真相，那些火燒島上的血與淚。

我曾記錄許多台灣重要的新聞事件，偶爾翻閱這些過去的照片，仍會為當年拍下的畫面所震懾。如果能藉由我拍的《流麻溝十五號》場景勾起大家對綠島黑牢的好奇，進一步想了解這段慘痛的歷史，那麼我的目的就達到了，也算替白色恐怖的受難者盡了一份心力。

Epilogue

I didn't step physically onto Green Island until much later in life, but I have heard of former political prisoners sharing their stories on the island long before. During the White Terror, they were sent to this remote offshore island because their political ideas were not accepted by the authority in power. Away from their family and their beautiful life, these elites in the society were incarcerated, facing the vast ocean and the horizon yet with nowhere to go and nowhere to turn to.

Back when I was still working as a journalist, I interviewed former political prisoners who were kept on the Island of Fire, and heard from them what happened there. I have always felt that oral history alone is not enough for us to really grasp the price they paid back then and that if only someone had just recorded it as it was, it would have been great. But there are no images left that were even close to the truth, only poster child propaganda created by the authority. As such, will the historical truth so tainted with blood be forgotten just like that? I wondered to myself.

In the 1990s, my work in journalism meant I had access to many former political prisoners, I thus became curious about the history of the White Terror and political incarceration in Taiwan, which further prompted me to photograph the former political prisoners. Featuring those who had been imprisoned for over 10 years, my project lasted a little over a year with photoshoots of over 70 to 80 people, but in the end, I had to abort the entire project. While

photographing them, I saw how humanity was completely twisted, and it was very difficult for me to go on.

I heard stories of how they were beaten and tortured during interrogation, but what shocked me most of all was that they were originally really good friends, but when they were imprisoned for the same case, they were divided due to the interrogation, causing former revolution comrades to become suspicious of one another, suspecting that someone sold them out. Even after many decades and well away from imprisonment, they are still filled with much hatred. During the interviews, I would hear them criticize their former comrades, which pained me so much that I couldn't bring myself to take the photo. Eventually, I had to give up the photography project.

In 1991, the Government Information Office then organized a tour to show journalists around the Green Island. I knew that it was arranged by the "authority" and that the scenes would be glorified and unreal, but Green Island prisons were rarely open to the public then and I didn't want to pass up the opportunity, so I joined the tour paid for by the government and stepped onto Green Island for the first time, so I could see for myself what it was like "inside the prison".

Back then there were few tourists on Green Island, and everything was still very rustic. The simple fishing village was much like my hometown Penghu, and it was hard to imagine that there used to be three prisons holding political prisoners and prisoners from Operation Clean Sweep. We were arranged to visit the Chongde New Village, and saw an entire row of prison cells cleaned up nicely without a trace of the many general prisoners and ideological prisoners incarcerated here all those years ago.

The reason Green Island was chosen as the place to detain people convicted of felonies was that it is surrounded by the ocean on all sides, and with its reef landform and mountain as barriers, there is no way to escape. Political prisoners back then were mostly elites in the society, such as doctors, teachers, architects, and engineers. While they were imprisoned on the Green Island, they helped out whenever they can. When there was no doctor, they took care of the patients; when there were not enough teachers, they took up teaching again; when no one knew how the construction should go, they rolled up their sleeves as architects and personally built the prisons that held them.

What I remembered the most was the place introduced as where they spent their "free time". When the weather is good, you can see the main island from there. I can't possibly imagine the desperation and helplessness they felt when they gazed at Taiwan from across

the waters.

In addition to the unfinished portrait project of former political prisoners, in 2012, I was invited by C.j. Tsao, author of the oral history collection Untold Herstory, to take photos of the female political prisoners held there in the late 1950s. One of the female political prisoners Shih Shui-Huan was executed by firing squad in 1956, so I only photographed the remaining 5 that survived. During the photo shoot, I heard many tales of their experiences in the prison on Green Island. But the past is the past and all we can do is document their lives now, the lives they have led after leaving the Green Island all those years ago.

At the end of 2021, former legislator Pasuya Yao went into the film industry and raised money to shoot a movie based on the oral history collection Untold Herstory. Both Yao and C.j. Tsao, the original author of the book, asked if I would be willing to check out the film site on Green Island and take some photos. I was very hesitant prior to my departure and even considered quitting. Taking beautiful stills was not my area of expertise, but I do so want to see the scenes for myself, and see if the scenes recreated were exactly as described by the former political prisoners all those years ago. Eventually, I left for Green Island with only three sets of changing clothes, and I told myself, I will return if I can't get any good shots. I ended up spending two weeks on Green Island with just these three sets of clothes.

I tried my best to shoot the stills that were not "stills", tried to recreate the prison as described by the former political prisoners of the 1950s, and document the movie scenes with silent photographs. These photographs were not taken for the sake of the film. Rather, I hope that with the film being made and the scenes on the Island of Fire recreated, I could imagine myself standing ashore on Green Island during the White Terror, and trying to photograph the truth that was not seen, the tears and blood on the Island of Fire.

I have documented many significant news events in Taiwan in the past, and sometimes, flipping through the photographs of past events, I am still struck by the footage I took then. If the photographs I have taken at the site of Untold Herstory have enticed your curiosity toward the prisons on Green Island and will want to further learn more about the history of this tragic period, then I have served my purpose and finally done something for the victims of the White Terror.

火燒島

流麻溝十五號
UNTOLD HERSTORY

作者：謝三泰｜監製：姚文智・湠臺灣電影股份有限公司｜責任編輯：賴譽夫｜美術設計：楊啟巽工作室｜序文英譯：柯乃瑜｜編輯出版：遠足文化｜行銷企劃：林芳如、余一霞、汪佳穎｜行銷總監：陳雅雯｜副總編輯：賴譽夫｜執行長：陳蕙慧｜社長：郭重興｜發行人兼出版總監：曾大福｜發行：遠足文化事業股份有限公司｜23141新北市新店區民權路108之2號9樓｜代表號：（02）2218-1417　傳真：（02）2218-0727｜客服專線：0800-221-029　Email：service@bookrep.com.tw｜郵政劃撥帳號：19504465　戶名：遠足文化事業股份有限公司｜網址：http://www.bookrep.com.tw｜法律顧問：華洋法律事務所・蘇文生律師｜印製：韋懋實業有限公司｜初版一刷 2022年7月｜ISBN：978-986-508-146-1｜定價：650元

國家圖書館出版品預行編目(CIP)資料

火燒島：流麻溝十五號／謝三泰作. — 初版. —

新北市：遠足文化事業股份有限公司, 2022.07

184面；15.5×23公分　ISBN 978-986-508-146-1

（平裝）　1. 攝影集　　958.33　　　　111008168